IMAGES
*of America*

# CALIFORNIA
# LIGHTHOUSE LIFE
## IN THE 1920s AND 1930s

# NOTICE TO MARINERS.

## LIGHT HOUSE

### ENTRANCE OF

# HUMBOLDT BAY,

### CALIFORNIA.

A FIXED WHITE LIGHT, FOURTH ORDER OF FRESNEL,
ILLUMINATING THE ENTIRE HORIZON.

The house is situated on the North Sands, three-fourths of a mile from the Inlet, and about midway between the bay and sea shores. It consists of a keeper's dwelling of one story and a half story, with tower rising 21 feet above the roof from the centre, both plastered and white-washed, and surmounted by an iron lantern painted red. The light is 53 feet above high water of spring tides, and should be seen in clear weather from the deck of a sea-going vessel, 12 nautical or 14 statute miles.

The latitude and longitude of the light, and the magnetic variation in the vicinity, determined by the Coast Survey, are as follows :

Lat................... 40° 46′ 04″ N.
Long............ ........124° 12′ 21″ W.
Mag. var........... 17° 04′ E. (April, 1854.)

The light will be exhibited for the first time on the night of the 20th of December, 1856, and thereafter until further notice.

By order of the Light House Board :

HARTMAN BACHE,

Maj. Topog'l Eng's Bt. Maj.

Office, Twelfth Light House District, }
SAN FRANCISCO, CAL., Dec. 1, 1856. }

IMAGES
*of America*

# CALIFORNIA
# LIGHTHOUSE LIFE
## IN THE 1920S AND 1930S

Wayne C. Wheeler
United States Lighthouse Society

ARCADIA
PUBLISHING

Published by Arcadia Publishing
Charleston SC, Chicago IL, Portsmouth NH, San Francisco CA

Printed in the United States of America

Library of Congress Catalog Card Number: 00-102245

For all general information contact Arcadia Publishing at:
Telephone 843-853-2070
Fax 843-853-0044
E-Mail sales@arcadiapublishing.com

For customer service and orders:
Toll-Free 1-888-313-2665

Visit us on the Internet at www.arcadiapublishing.com

# Acknowledgments

The majority of the photos in this book were taken by former Lighthouse Service employee Irving Conklin during the period from 1929 to 1932. They were donated to the United States Lighthouse Society. A few other photos from the society archives or other sources have been included to illustrate certain points, such as how the lighthouse appeared either before or after the Conklin series was photographed.

Those photographs dating from years other than the Conklin era are so noted, as well as those photos from sources other than the Conklin collection or society archives.

The location maps are courtesy of Rusty Nelson.

Further information about lighthouses may be obtained from: The U.S. Lighthouse Society, 244 Kearny Street, Fifth Floor, San Francisco, CA 94108; The Great Lakes Lighthouse Keepers Association, 4901 Evergreen Road, Dearborn, MI 48128; and Lighthouse Antiques (books, photos, etc.), Kenrick A. Claflin & Son, James W. Claflin, 30 Hudson Street, Northborough, MA 01532.

# CONTENTS

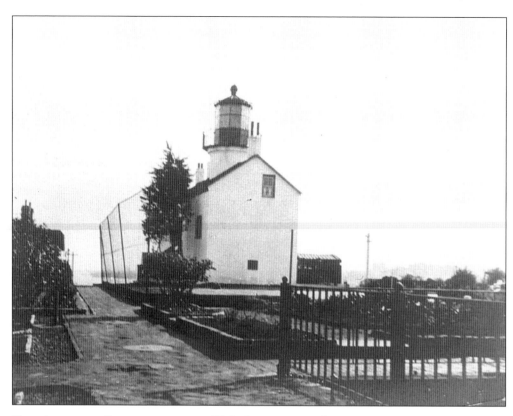

THE ALCATRAZ LIGHTHOUSE IN A U.S. LIGHTHOUSE SOCIETY PHOTOGRAPH TAKEN IN FEBRUARY 1908 (ABOVE) AND AN ENGINEER'S DRAWING OF THE LAYOUT IN 1854 (BELOW).

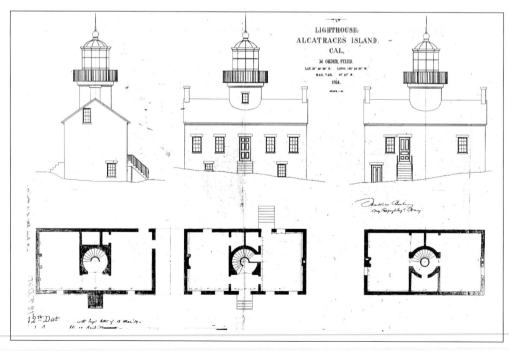

# INTRODUCTION

California's lighthouses were established as a direct result of the Gold Rush. In 1850, Congress appropriated funds to construct eight lighthouses on the West Coast (seven in California and one in Washington Territory); however, due to some question regarding the original award of the contract and a Senate Select Committee investigation, the project was delayed for two years. Finally, the firm of Gibbons and Kelly, of Baltimore, MD, was awarded the contract. Their vessel, the *Oriole*, proceeded to the West Coast, sailing around the Horn arriving in San Francisco Bay in January 1853. The vessel had transported all the necessary materials to construct the eight stations with the exception of material for the walls. Locally made bricks, rubble stone, or granite was procured for that purpose. They dispatched crews to some of the locations selected years earlier by Topographical Engineer Major Hartman Bache, so that several of the lighthouses were under construction at the same time. A single design was used for all eight lighthouses, with a few variations due to terrain.

During the initial stages of construction, the Lighthouse Board, newly created in 1852, sent a change order to the contractor containing instructions not to install the lamp-reflector system specified in the original contract. The change order stated that Fresnel lenses from France were being procured and would be sent for installation in all West Coast lighthouses. Although a far superior lighting apparatus, some of the lenses were too large for the newly constructed lantern rooms and it was necessary to rebuild a few.

The first lighthouse to become operational on the West Coast was that on Alcatraz Island, June 1, 1854. While the other seven were being completed, Congress authorized funds to construct a second set of eight lighthouses; three more for California (Santa Barbara, Point Bonita, and Crescent City) and five in what are now the states of Oregon and Washington.

At the outbreak of the Civil War all 16 West Coast light stations were in operation. Due to the hostilities, further lighthouse construction on the West Coast was mainly delayed until the 1870s.

By 1930, California boasted 40 light stations, 4 having been discontinued—"old" Point Loma replaced by "new" Point Loma in 1890; Humboldt Bay was replaced by Table Bluff in 1892; Santa Barbara was destroyed by an earthquake in 1925; and Mare Island was replaced by Carquinez Strait in 1910.

The last classical light station established in California was on Anacapa Island in 1932.

This book depicts lighthouse life in a quieter era, an era bordering on the Great Depression. It was a time when our keepers were thankful to have a secure means of employment, keeping the lights burning to protect the continuous parade of ships plying the waters along California's rugged coastline.

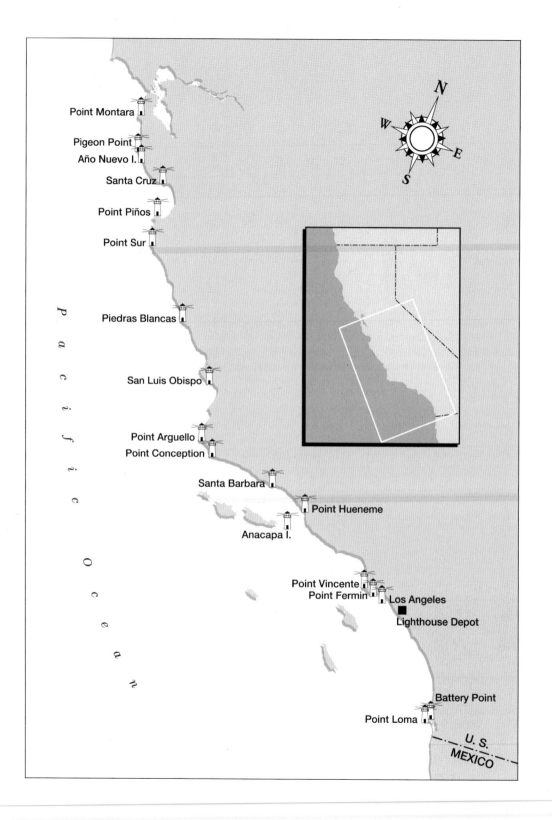

Point Montara

Pigeon Point
Año Nuevo I.

Santa Cruz

Point Piños

Point Sur

Piedras Blancas

San Luis Obispo

Point Arguello
Point Conception

Santa Barbara

Point Hueneme

Anacapa I.

Point Vincente
Point Fermin
Los Angeles
Lighthouse Depot

Battery Point
Point Loma

U. S.
MEXICO

*Pacific Ocean*

N
W        E
S

# One

# THE SOUTH COAST

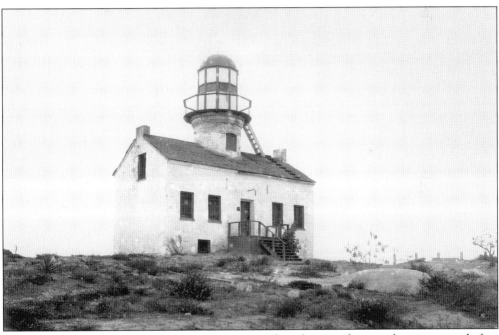

**THE OLD POINT LOMA LIGHTHOUSE, C. 1932.** This photograph was taken one year before the Cabrillo National Monument was created, which included this structure. The lighthouse, one of the original eight authorized for the West Coast, was completed in 1855. Its location of 425 feet above sea level made the light ineffective to vessels entering San Diego Bay and was often obscured to those at sea during periods of low lying clouds. In 1891 a new light station was completed at the base of the hill and old Point Loma was discontinued; it subsequently fell into disrepair.

Although the army used the structure for a radio station for a few years in the 1920s, overall the lighthouse continued to deteriorate until the national monument was created. The National Park Service restored the structure and nicely interprets it to reflect lighthouse life as it might have appeared in the 1890s.

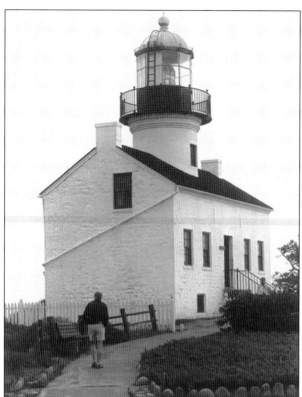

THE ORIGINAL POINT LOMA LIGHTHOUSE AS IT APPEARS TODAY, A CORNERSTONE OF THE CABRILLO NATIONAL MONUMENT.

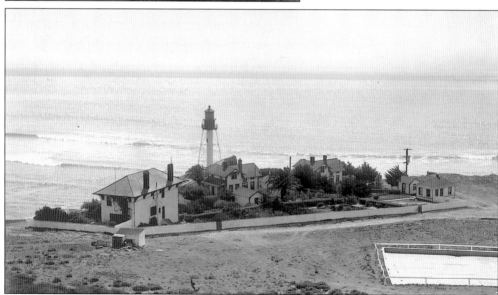

THE NEW POINT LOMA LIGHT STATION (1891) AT THE ENTRANCE TO SAN DIEGO BAY. The skeletal tower is the only tower of this type on the West Coast. All the original buildings remain. The dwellings are occupied by the families of the personnel stationed at the San Diego Coast Guard Air Station. The white object at right is a rain catchment basin. The West Coast is generally dry from April through November and water is a scarce commodity. During the rainy season water is pumped from the basin to cisterns to be used during dry months.

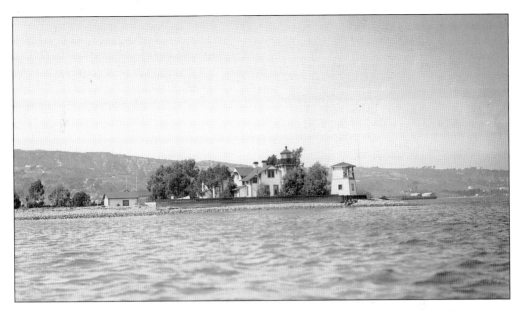

**THE BALLAST POINT LIGHT STATION, ESTABLISHED INSIDE THE ENTRANCE TO SAN DIEGO HARBOR IN 1890 TO ASSIST VESSELS IN LOCATING THE ENTRANCE AND STEERING CLEAR OF A POINT OF LAND THAT JUTS OUT INTO THE CHANNEL.** The station is an exact sister of those constructed in the same year at San Luis Obispo and Table Bluff. Even the arrangement of the main buildings is alike. The low structure at left is the boathouse, and at the far right is the bell fog signal house. In the 1950s this station was razed to allow for the expansion of a navy submarine base.

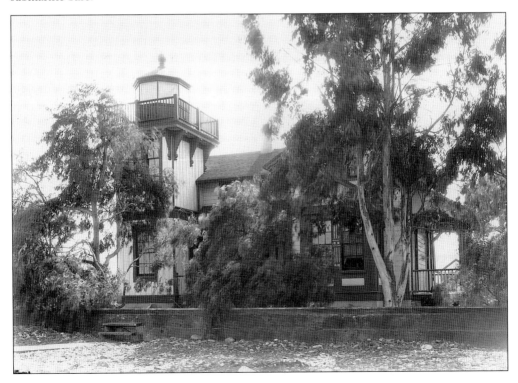

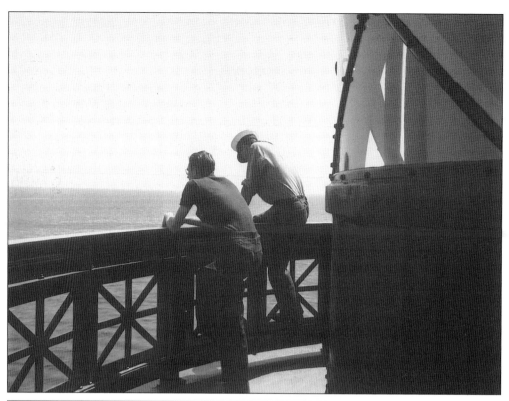

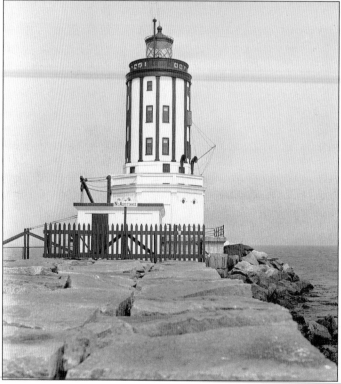

**Two Los Angeles Harbor Lighthouse** KEEPERS DEEP IN DISCUSSION ON THE GALLERY DECK OF THE LIGHTHOUSE.

**THE LOS ANGELES HARBOR LIGHTHOUSE.** Constructed of cast iron in 1913, this is often referred to as the "Angels Gate" lighthouse. The distinctive tower, the only one of this design in the country, is located on the end of a long rubble stone breakwater. It is so isolated that the keepers' families lived ashore.

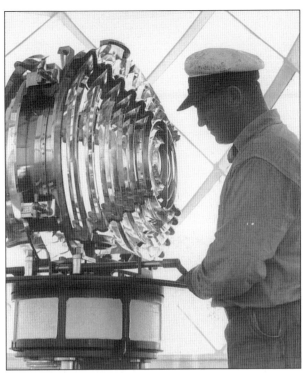

**THE KEEPER OF THE LOS ANGELES LIGHTHOUSE INSPECTING THE LENS.** This fourth-order clam shell-style Fresnel lens produced a flashing green light every 15 seconds visible for 14 miles.

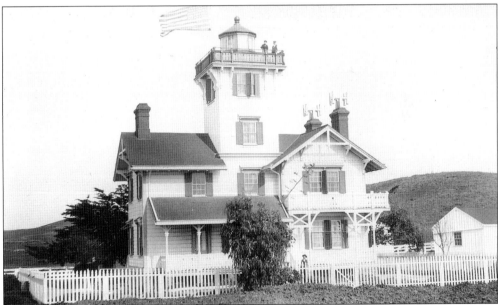

**POINT FERMIN, C. 1890.** This beautiful, redwood Victorian lighthouse, situated on a bluff near San Pedro, was one of three of this design built on the West Coast in the 1870s. Sadly, the other two, Point Hueneme, CA, and Point Adams, OR, no longer exist. The two-family station was converted into a submarine lookout post during World War II. After the war the structure was transferred to the City of Los Angeles Park Department. Today the lighthouse sits in a public park and serves as the home of the gardener. (Courtesy of the National Maritime Museum, San Francisco, CA.)

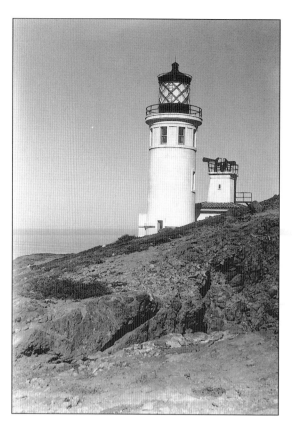

THE ANACAPA ISLAND LIGHT STATION. A remote station, and the last classical light station constructed in California (1932), it is also the only lighthouse in the Channel Islands. The station buildings reflect the Spanish style of architecture popular in Southern California. The tower contained a third-order Fresnel lens that produced a white flashing light visible for up to 23 miles. The structure to the right of the tower is the fog signal building, which supported a diaphone fog signal. Although the station is still operated by the U.S. Coast Guard, the family quarters and much of the property has been transferred to the Channel Island National Seashore.

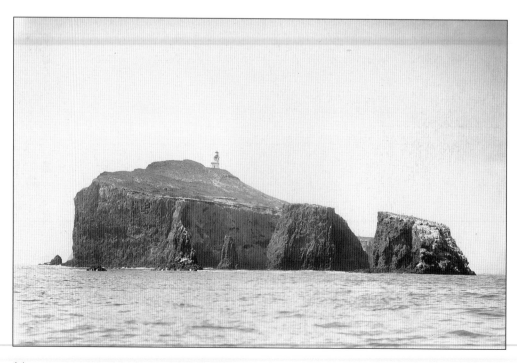

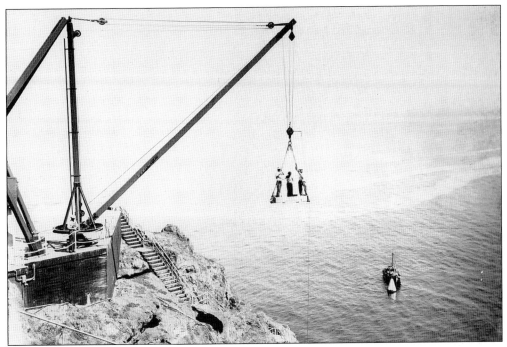

A SET OF CRANES ON ANACAPA ISLAND, USED TO BRING SUPPLIES AND PERSONNEL TO THE TOP OF THE BLUFF.

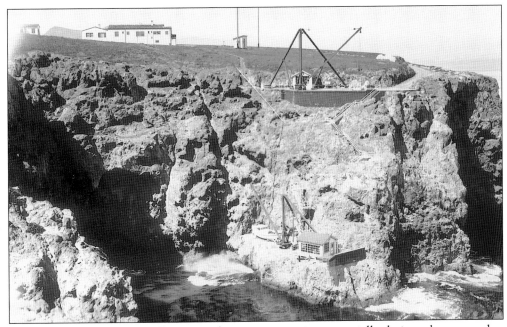

DWELLINGS AT TOP LEFT. This was a dangerous operation, especially during adverse weather conditions. A fall from the platform resulted in the death of one keeper in the 1930s. In November 1934, a keeper's wife was seriously injured in a fall. The battleship *California*, operating in the area, was notified. The crew dispatched a small boat and took the woman to a hospital on the mainland, where she recovered.

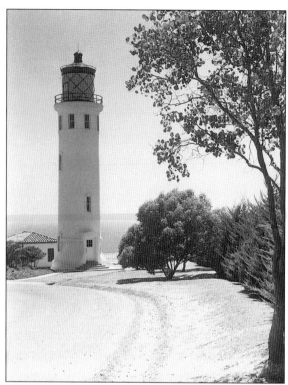

**POINT VINCENTE.** Established in 1926, this classical light station was the next to last constructed in California. It is located in the exclusive Pacific Palisades section of Los Angeles. The Spanish-style architecture reflects the homes in the area. Today Coast Guard personnel stationed at various units in the area reside in the dwellings.

A VIEW OF THE POINT VINCENTE LIGHT STATION FROM THE LANTERN ROOM.

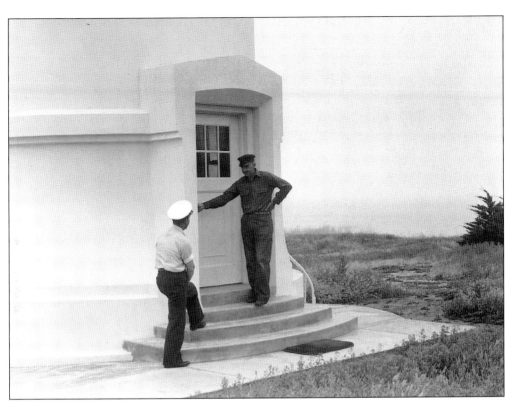

Two keepers in different uniforms at the base of the Point Vincente tower.

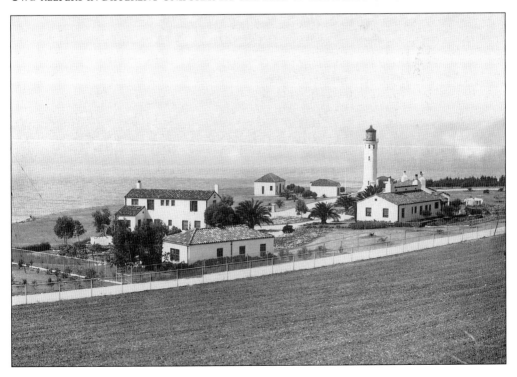

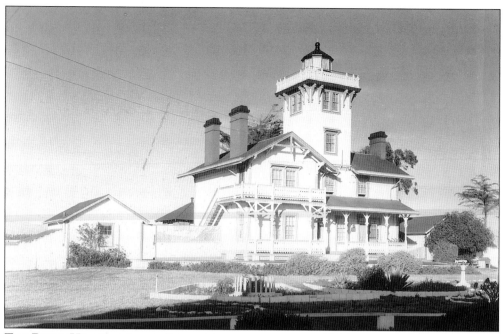

THE POINT HUENEME LIGHT STATION, CONSTRUCTED IN 1874, THE SAME YEAR AS SISTER STATION POINT FERMIN. In 1941, in order to dredge a new harbor, the lighthouse was sold and moved to become a yacht club for a few years. Eventually it was razed.

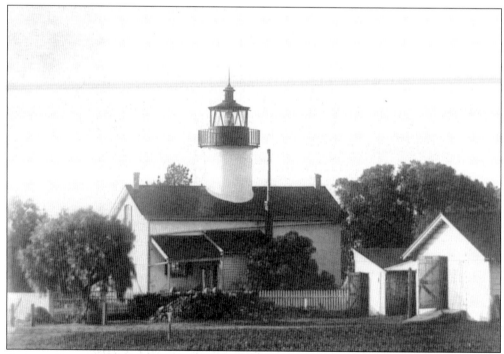

A REAR VIEW OF THE SANTA BARBARA LIGHTHOUSE. Completed in 1856, it was one of the second set of eight lighthouses constructed on the West Coast in the 1850s. For a number of years female keeper Julia Williams was in charge.

KEEPER A.J. WEEKS TENDING HIS GARDEN IN FRONT OF THE SANTA BARBARA LIGHTHOUSE WHILE VISITORS ADMIRE THE VIEW FROM THE LANTERN ROOM.

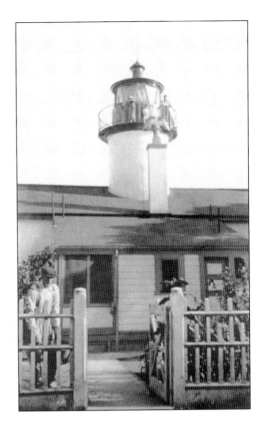

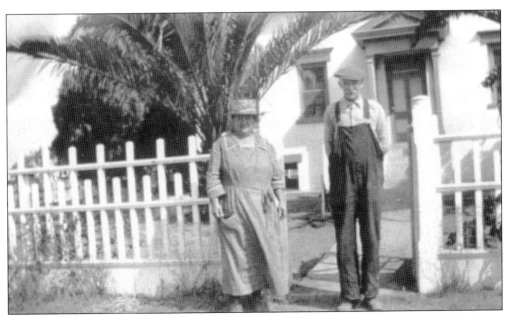

KEEPER A.J. WEEKS AND HIS WIFE PRIOR TO 1925.

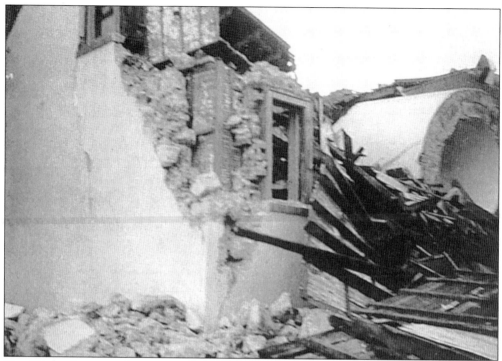

**THE SANTA BARBARA LIGHTHOUSE, SHOWING THE EFFECTS OF THE 1925 EARTHQUAKE.** The large cylinder lying on its side is the tower that extended up through the middle of the dwelling.

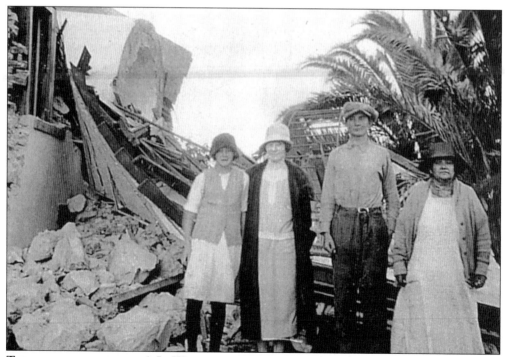

**THE FAMILY OF KEEPER A.J. WEEKS POSES IN FRONT OF THE DESTROYED LIGHTHOUSE.** Miraculously, no one was hurt.

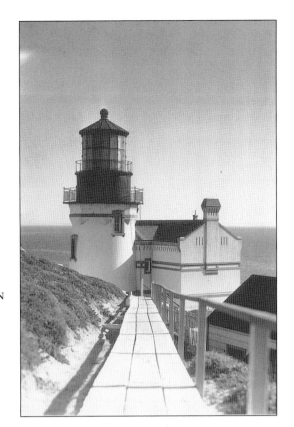

THE POINT CONCEPTION TOWER AND FOG SIGNAL BUILDINGS, CONSTRUCTED IN 1881 TO REPLACE THE ORIGINAL 1856 STRUCTURE THAT WAS LOCATED ON TOP OF THE BLUFF. The duplex dwelling remained atop the bluff, requiring the keepers to make a steep descent to the lighthouse. The dwelling pictured below was constructed in 1889 when the lighthouse was rebuilt.

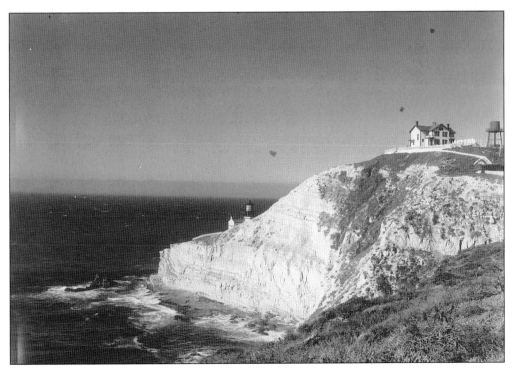

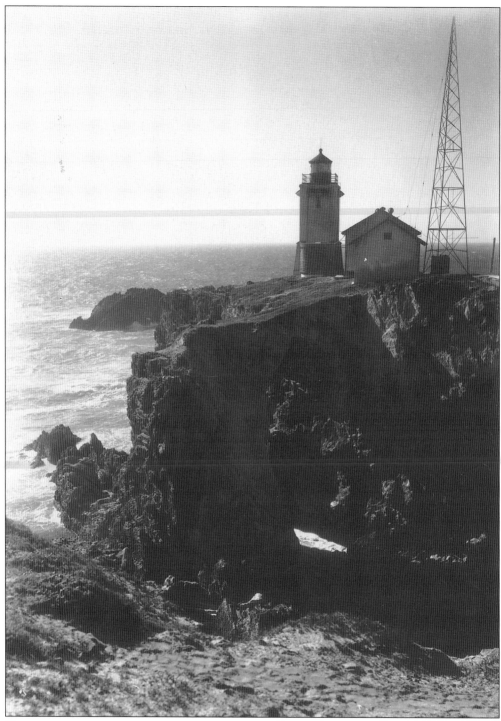

**THE THIRD SET OF BUILDINGS CONSTRUCTED AT POINT ARGUELLO LIGHT STATION.** The first Point Arguello Lighthouse was constructed in 1901. Erosion necessitated replacement in 1911, and again in 1934. The skeletal, pyramidal tower is a radio beacon antenna, an aid to navigation introduced in 1923.

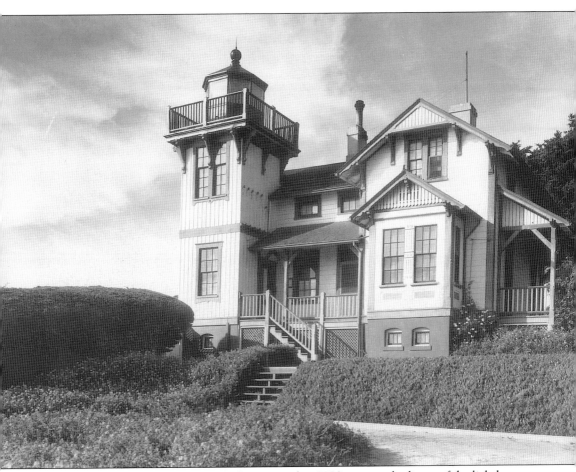

**THE SAN LUIS OBISPO LIGHTHOUSE.** Constructed in 1890, it was a duplicate of the lighthouses at Ballast Point (San Diego) and Table Bluff, Humboldt Bay.

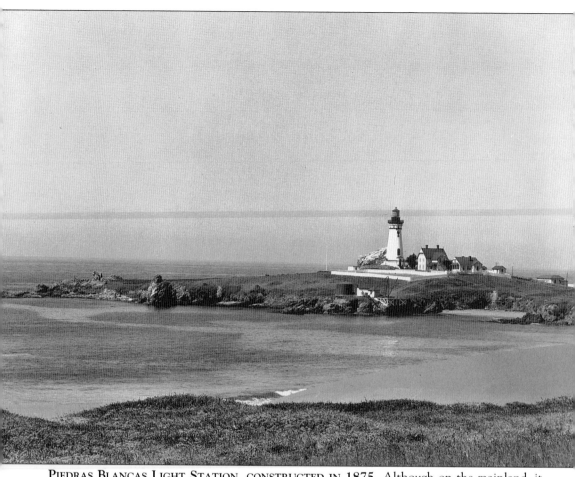

**PIEDRAS BLANCAS LIGHT STATION, CONSTRUCTED IN 1875.** Although on the mainland, it was in so remote a location for much of the 19th century that it may as well have been on an island. Supplies were brought to the station by a Lighthouse Service tender and landed at the small dock in the foreground. The large house is a duplex for assistant keepers. The small house is the head keeper's dwelling.

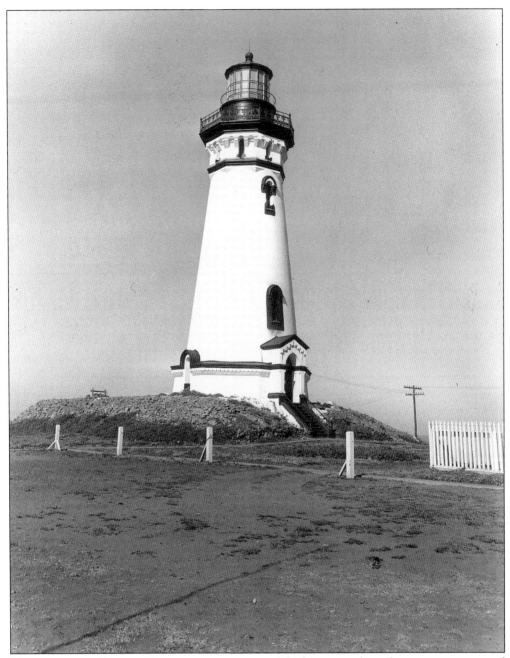

**THE BEAUTIFUL PIEDRAS BLANCAS LIGHT TOWER.** The lantern and watch rooms were removed from the beautiful light tower in the 1940s to allow the installation of an aero-beacon. The original first-order Fresnel lens is on display in the nearby town of Cambria, CA.

THE BARN, TRIPLEX ASSISTANT KEEPERS' DWELLING, AND THE KEEPER'S DWELLING OF THE POINT SUR LIGHT STATION SHORTLY AFTER CONSTRUCTION IN 1889.

THE POINT SUR LIGHT STATION, COMBINATION TOWER, AND FOG SIGNAL BUILDING (AT LEFT). The keepers of this station witnessed the crash of the navy dirigible *Macon* in 1934.

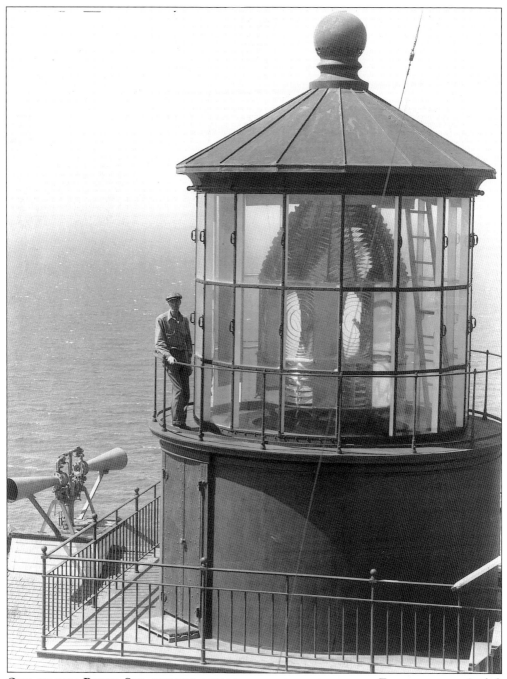

ONE OF THE POINT SUR KEEPERS DWARFED BY THE FIRST-ORDER FRESNEL LENS. At left are the trumpets for the air siren fog signal. The lens is now on display in the Monterey Maritime Museum.

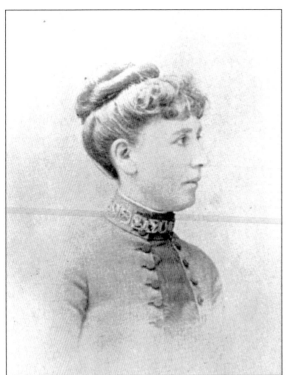

**EMILY FISH, KEEPER OF THE POINT PIÑOS LIGHTHOUSE FOR 21 YEARS.** Emily is pictured wearing the uniform she devised. Although there were many women lighthouse keepers over the years, there was never an official uniform.

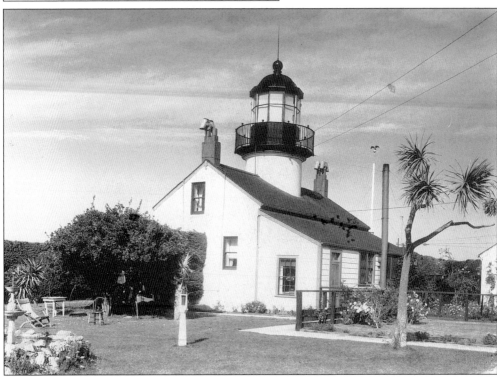

**THE POINT PIÑOS LIGHTHOUSE, C. 1930.** This was one of the original eight West Coast lighthouses.

THE ORIGINAL POINT PIÑOS
LIGHTHOUSE THIRD-ORDER LENS,
STILL IN USE IN THE LANTERN
ROOM. The lighthouse is open to
the public on weekends.

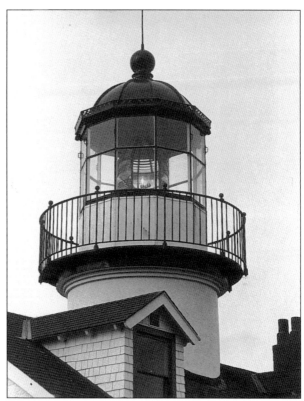

THE POINT PIÑOS LIGHTHOUSE.
The covered entrance way and
dormer window were added to the
rubble stone lighthouse in 1910.

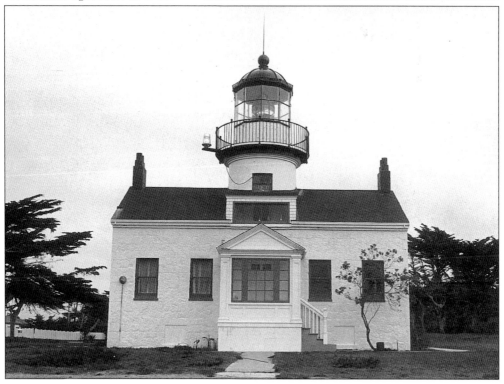

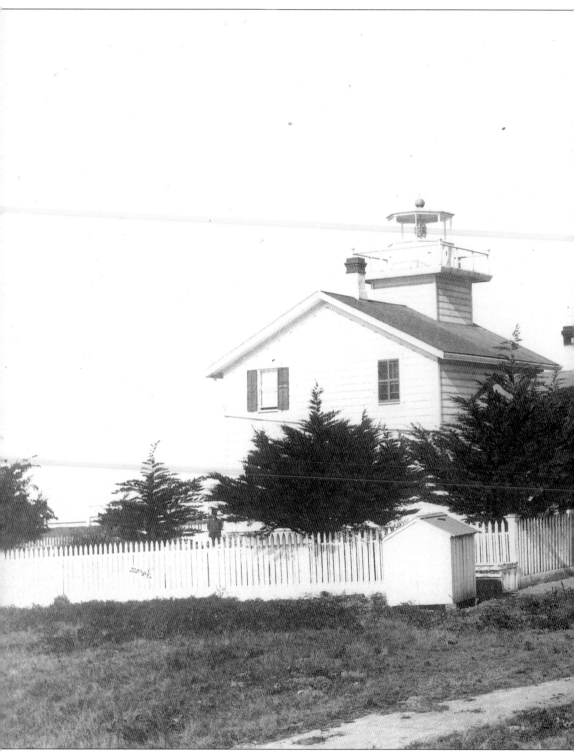

**THE SANTA CRUZ LIGHTHOUSE, C. 1887.** Laura Hecox, daughter of early keeper Adna Hecox, obtained the position after her father died. She served for 33 years. Note the buggy at right. The

station was discontinued in 1941 and razed in 1948. (Courtesy of National Archives.)

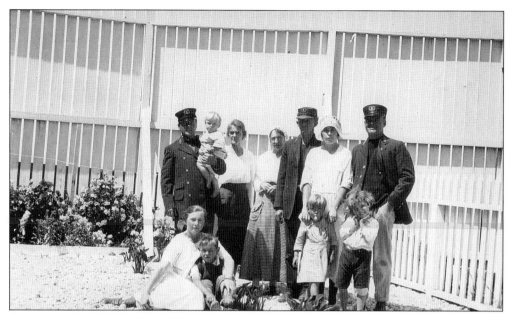

Año Nuevo Lighthouse keeper Otto Becker and his wife (center), with his assistants and their families. The group is posing in front of a wind break that was constructed to protect a garden.

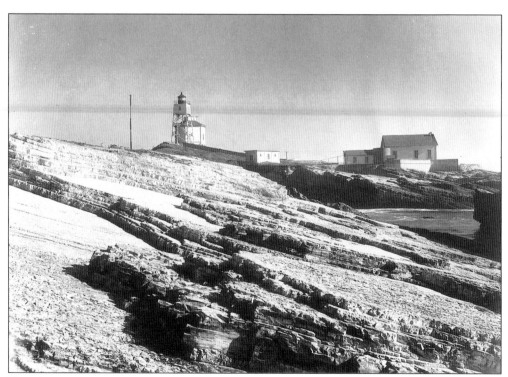

The Año Nuevo Island Light Station, established in 1875 as a fog signal station. In 1900 a lantern room was installed on the octagonal water tank (visible behind the tower). The metal tower replaced the water tank as the lighthouse in 1914. The fog signal building is at right.

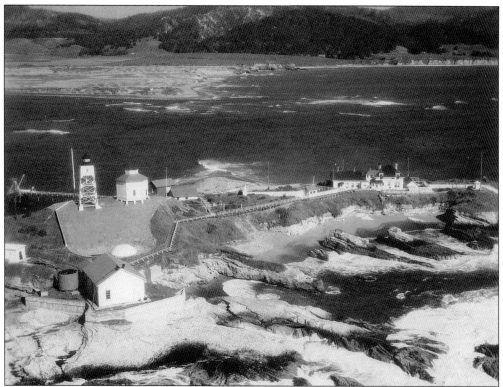

**AÑO NUEVO ISLAND.** The fog signal building is at the lower left, and the 1914 light tower and water tank are at the top left. The keeper's dwelling and assistant duplex are at the far right. The mainland can be seen in the background, some 1,000 yards distant.

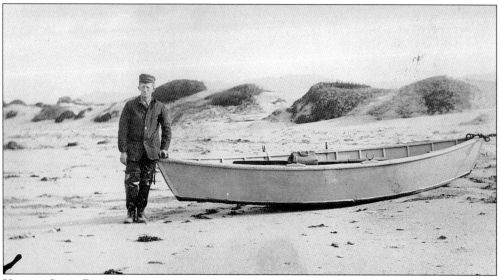

**KEEPER OTTO BECKER AND THE STATION BOAT.** In 1884 two keepers and their farmer guests drowned when returning to the mainland one evening. The keepers' wives, stranded on the island, started the fog signal during clear weather and hoisted the flag upside down. These actions alerted the passing steamer S.S. *Los Angeles*, which came to their rescue.

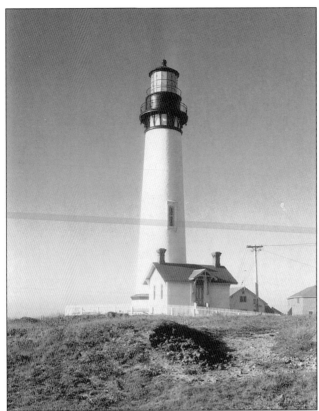

**THE PIGEON POINT LIGHT STATION TOWER.** This 1870 design was employed at several light stations around the country, including Cape Hatteras, NC; St. Augustine, FL; and Sand Island, AL. The height of the towers varied; Pigeon Point's is 115 feet high.

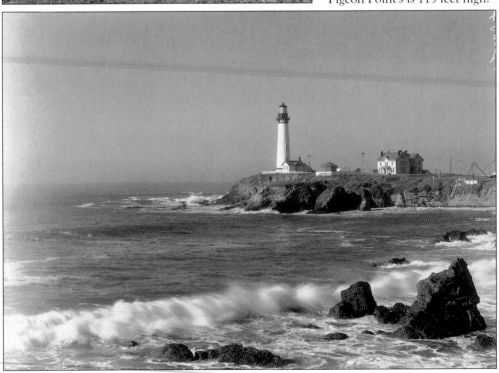

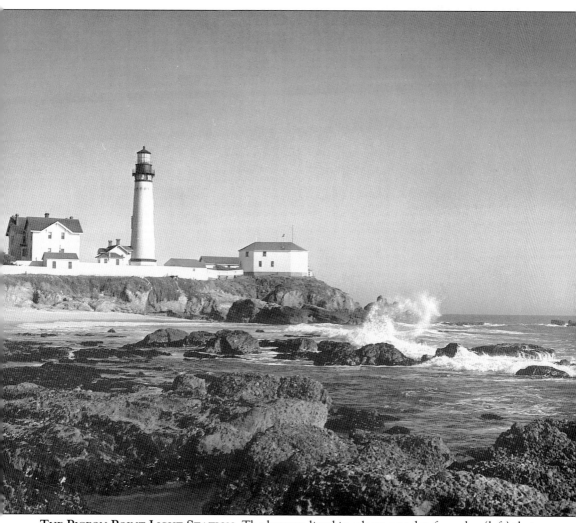

**THE PIGEON POINT LIGHT STATION.** The keepers lived in a large wooden four-plex (left) that was replaced by four ranch-style houses in the 1950s. The building at right contains a double water tank.

A Point Montara keeper cleaning the fog signal air compressor.

The Point Montara Light Station, established in 1875 as a fog signal station (no light tower). In 1900 a small post light was established. The 1875 duplex dwelling is at right; the fog signal building is to the left.

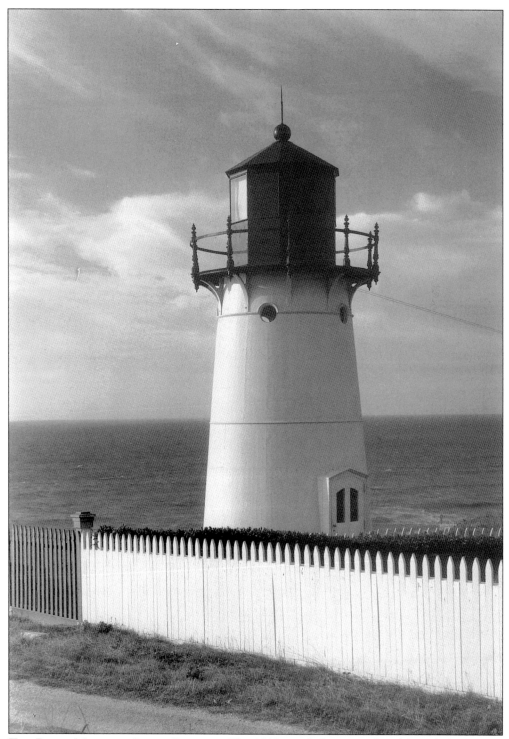

**THE POINT MONTARA LIGHT STATION.** The 1900 post light was replaced by a skeletal tower in 1912 and the present cast-iron tower (above) replaced it in 1926. This tower is a design used in several East Coast locations.

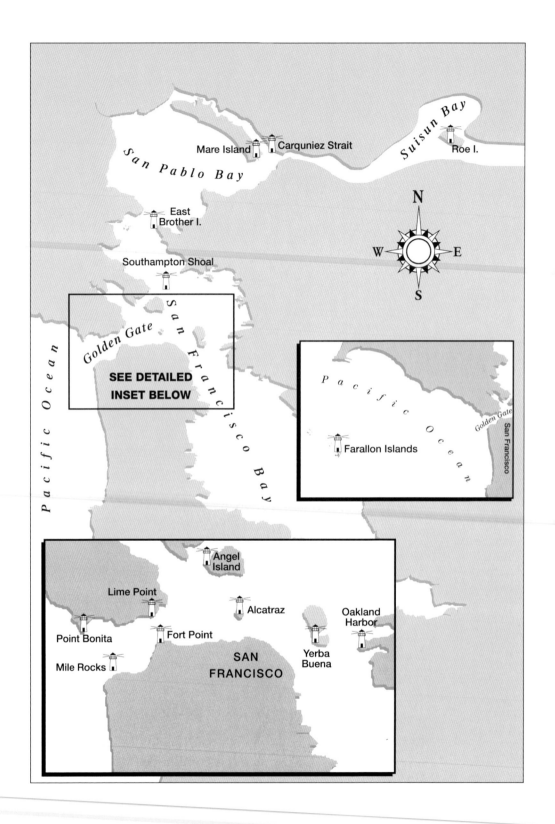

# Two

# SAN FRANCISCO BAY

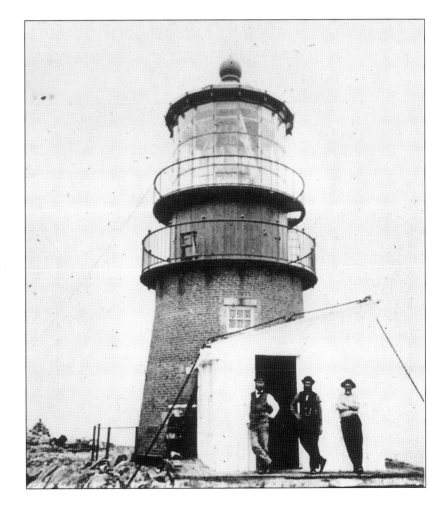

**WORKMEN IN FRONT OF THE JUST-COMPLETED FARALLON ISLAND LIGHTHOUSE IN 1856.** The Farallon Islands, although 25 miles off San Francisco's coast, lie in the path of the shipping lanes into the bay and are a hazard to coastal commerce as well.

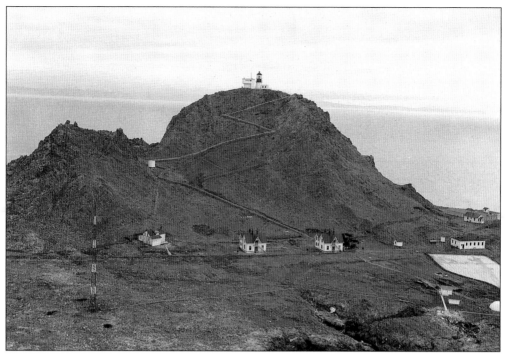

**THE ORIGINAL KEEPER'S DWELLING (LOWER LEFT).** The two Victorian duplexes (center) were constructed in the 1870s. A rain catchment basin is visible at right. (Courtesy U.S. Coast Guard.)

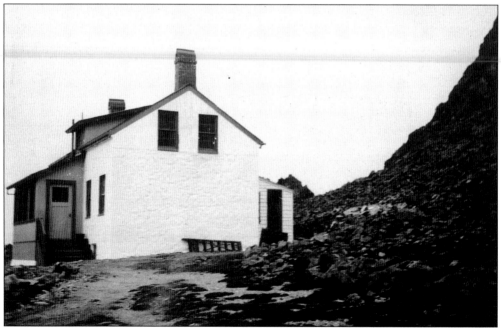

**THE FARALLON ISLAND LIGHT STATION, ONE OF THE ORIGINAL EIGHT STATIONS SLATED FOR THE WEST COAST.** Because of limited space on top of the 425-foot-high mountain, the keeper's house was separated from the tower and constructed at the base of the mountain.

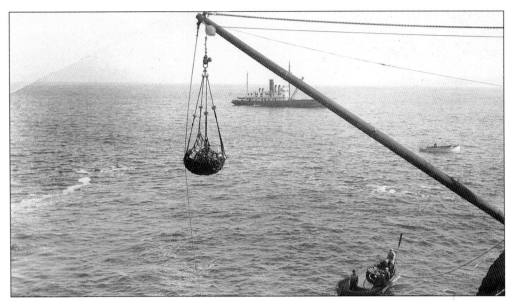

**A CRANE AND A DEVICE KNOWN AS A BILLY PUGH NET, WHICH BROUGHT PERSONNEL AND SUPPLIES TO THE ISLAND.** A Lighthouse Service tender is visible in the background of this 1937 photo; the ship's supply boat is under the net.

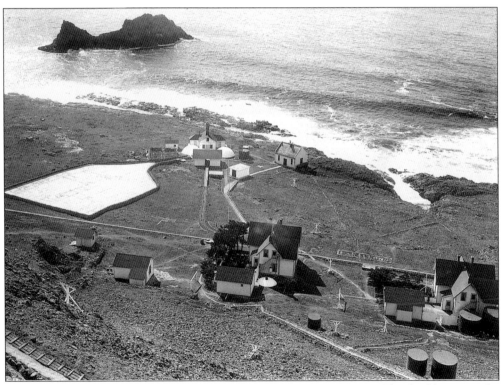

**A VIEW OF THE STATION FROM HALF-WAY UP THE MOUNTAIN.** The buildings in the distance are fog signal buildings. A tramway runs in front of the dwellings and down to the fog signal buildings.

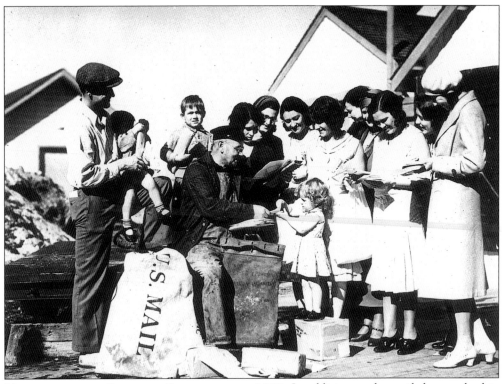

**MAIL DAY AT THE FARALLON ISLANDS DOCK, 1929.** In addition to the mail the supply ship brought all food goods and supplies.

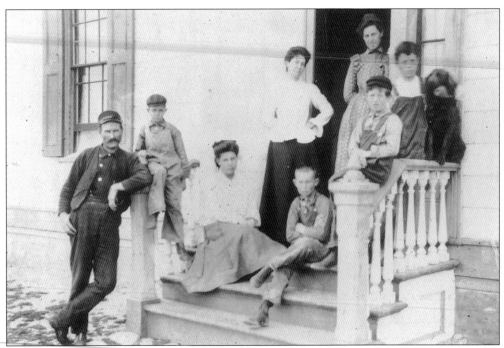

**THIRD ASSISTANT KEEPER KANEEN AND HIS FAMILY IN 1904.** (Courtesy Peter White.)

**PADDY, THE SECOND FARALLON MULE, AND THE KEEPERS' KIDS.** Paddy was used to pull the tramway cart along the 3,400 feet of narrow-gauge rail on the island. To the annoyance of the keepers Paddy learned that "boat day" meant work day. When the steamer sounded her whistle approaching the island, Paddy would run off and hide among the rocks until she was brought back to do her duty. (Courtesy Peter White.)

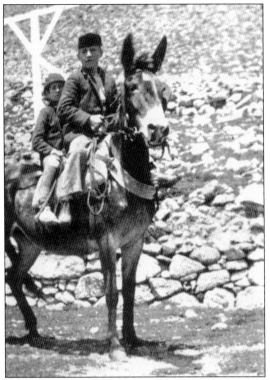

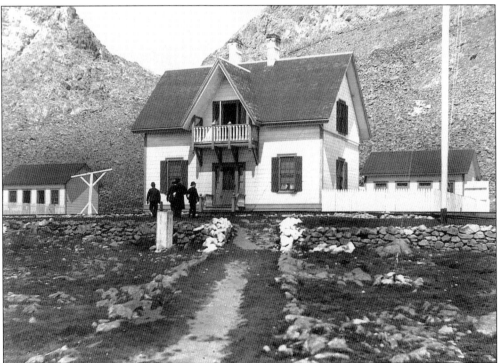

**ONE OF THE 1870S VICTORIAN DUPLEXES.** The cross at left was part of a call bell system that linked the dwellings, lighthouse, and fog signal buildings.

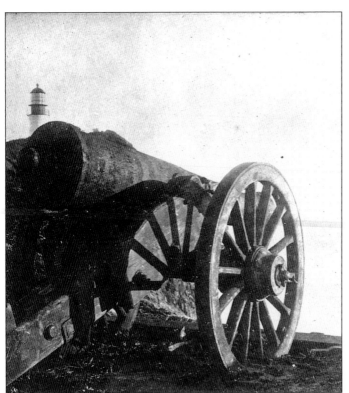

**THE ORIGINAL 1855 POINT BONITA LIGHT STATION TOWER (BEHIND THE CANNON).** Prior to 1877 this was the first fog signal on the West Coast (1857–1859). Because the tower was above the layers of fog prevalent in the area, the lantern room and lens were relocated to a new tower closer to sea level in 1877.

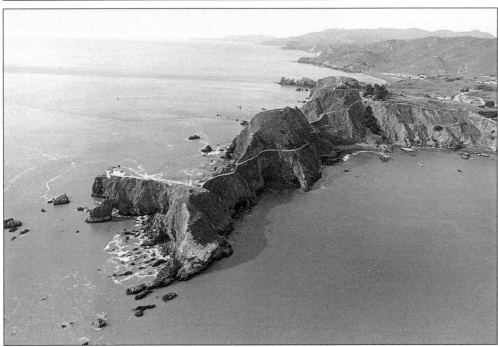

**THE SECOND LIGHT TOWER, CONSTRUCTED IN 1877 AT THE END OF THE SPINE OF LAND AT LEFT.** The keeper's dwellings and other buildings are at the extreme right. (Courtesy National Park Service, Golden Gate National Recreation Area.)

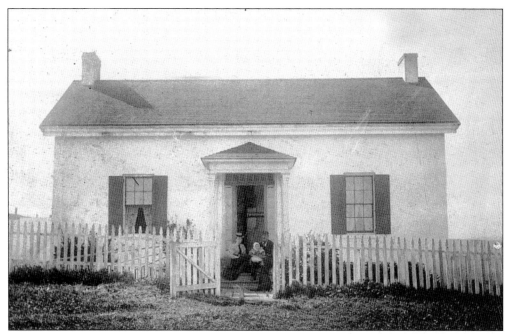

KEEPER NILES FREY AND HIS FAMILY ON THE STEPS OF THE ORIGINAL POINT BONITA DWELLING. Like the Farallons, the placement of the tower was such that there was no room for the dwelling. (Courtesy National Park Service.)

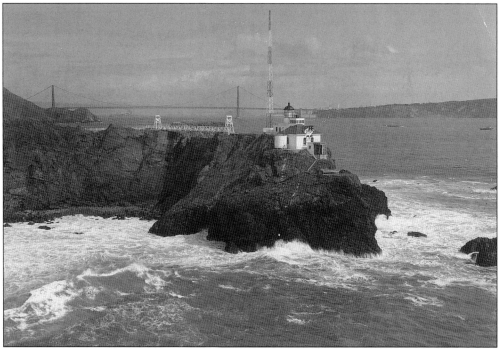

THE 1877 POINT BONITA LIGHTHOUSE WITH THE GOLDEN GATE BRIDGE IN THE BACKGROUND. The large antenna is for the radio beacon. Note the suspension bridge to the lighthouse. (Courtesy U.S. Coast Guard.)

SECOND ASSISTANT KEEPER NILES FREY, WHO SERVED AT POINT BONITA FROM 1896 TO 1900. (Courtesy National Park Service.)

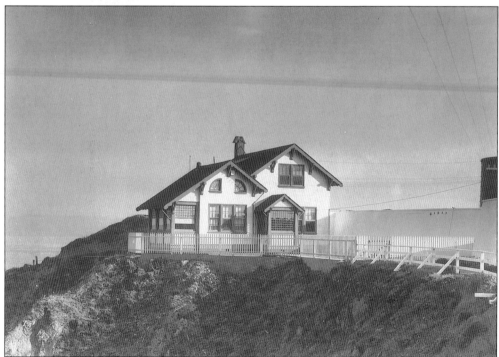

THE POINT BONITA FOURTH ASSISTANT KEEPER'S DWELLING, LOCATED AT THE EAST END OF THE BRIDGE TO THE LIGHTHOUSE.

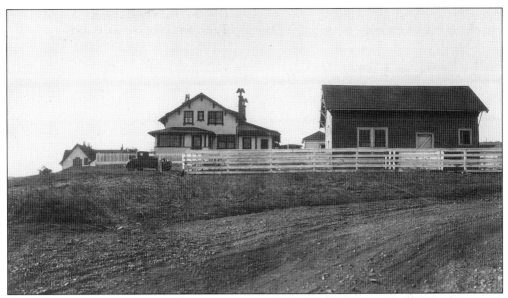

THE SECOND ASSISTANT KEEPER'S DWELLING AND BARN IN 1929.

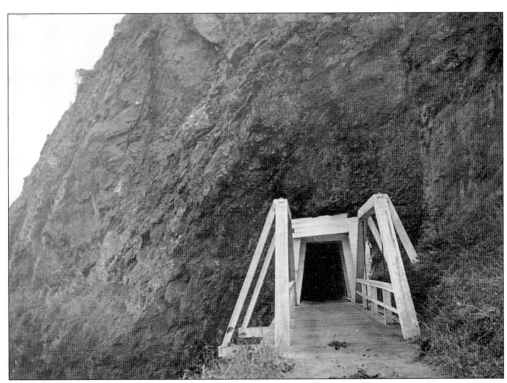

THE POINT BONITA LIGHTHOUSE, 1907. Originally the trail to the 1877 light tower went around this hill, to the left, via a wooden walkway. Because the cliff is extremely unstable the walkway kept falling into the Golden Gate Strait. To solve the problem the Lighthouse Service hired Chinese laborers to pick-axe a 180-foot-long tunnel through the hill.

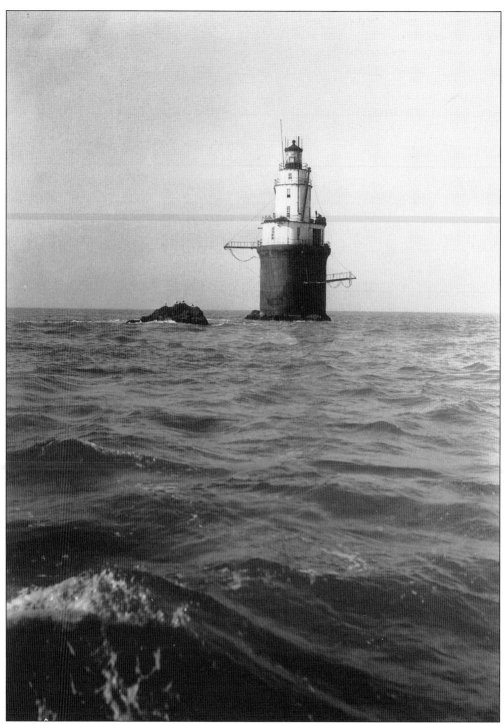

**MILE ROCK LIGHTHOUSE.** In 1901 the steamer *Rio de Janeiro* ran aground on Fort Point Ledge and sank with the loss of all 200 people aboard. The ship was never found. As a result of this disaster, the Lighthouse Service constructed Mile Rock Lighthouse in 1906. It is the only caisson-style lighthouse on the West Coast. The keepers rotated watches as the families lived ashore.

**THE FORT POINT LIGHT TOWER ON THE PARAPETS OF FORT POINT.** The small structure at right is the oil house.

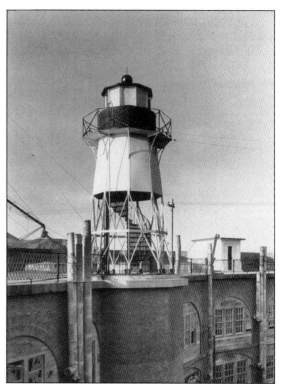

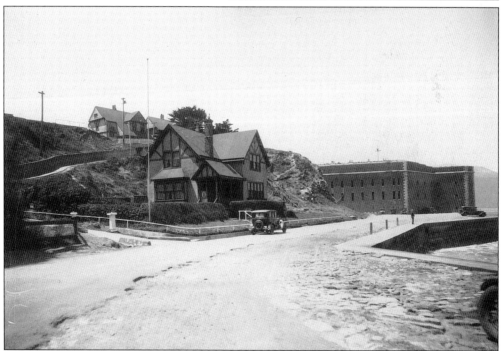

**THE PRINCIPAL KEEPER'S DWELLING AT FORT POINT, WITH THE TWO ASSISTANTS' DWELLINGS BEHIND ON THE BLUFF.** A bridge connected the bluff to the top of the fort, allowing the keepers access to the tower. The dwellings were razed to make way for the Golden Gate Bridge in 1934.

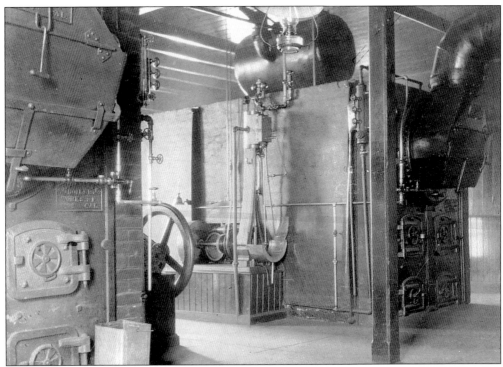

LARGE BOILERS THAT SUPPLIED THE STEAM TO POWER THE FOG SIGNAL AT LIME POINT.

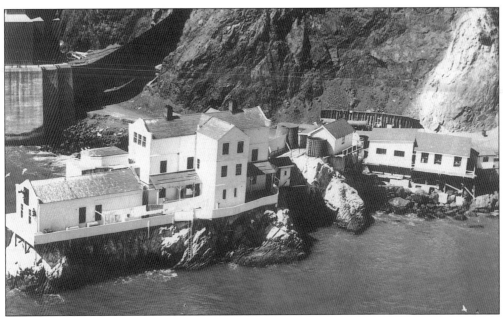

THE LIME POINT FOG SIGNAL STATION, ESTABLISHED IN 1883 (NO LIGHT TOWER). In 1900 a small lens-lantern was hung on one corner and Lime Point became a light station. The fog signal building is at left. The horn can be seen protruding from the wall; below it is the lens lantern on the corner of the building. The keepers lived in the triplex at right. The northern pier of the Golden Gate Bridge can be seen at the top left.

A TYPICAL, 8-DAY LENS-LANTERN USED AT LIME POINT (OPPOSITE PAGE) AND ANGEL ISLAND (BELOW).

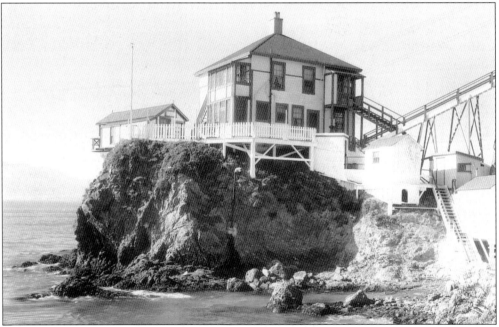

THE ANGEL ISLAND LIGHT STATION ON ANGEL ISLAND'S POINT KNOX, ACROSS FROM LIME POINT, AT THE ENTRANCE TO RACCOON STRAIT. This station was established in 1886 as a bell fog signal station to assist fog-bound ferries heading for Sausalito. As at Lime Point, a small lens-lantern was hung from the front of the bell house in 1900, upgrading the facility to a light station. For many years Juliet Nichols was the only keeper at this station. Her husband, Commander Henry Nichols, had been in charge of California lighthouses. When he died in the Spanish-American War, she was offered the position of keeper of this station. Her mother, Emily Fish, was keeper at Point Piños at the same time (see p. 28). The fog signal house is at left.

51

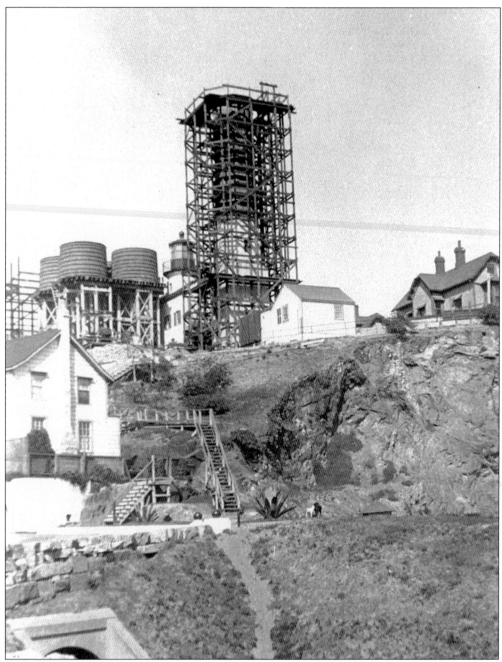

THE ORIGINAL ALCATRAZ LIGHT STATION, THE FIRST ONE LIGHTED ON THE WEST COAST (SEE PHOTO AND DRAWING ON P. 6). The original lighthouse was slightly damaged by the 1906 earthquake. By 1909 the new military prison on the island was about to overshadow the old lighthouse and the Lighthouse Service designed this replacement, a reinforced concrete structure. The scaffolding surrounds the new tower. The old lighthouse is visible at left, just behind the scaffolding.

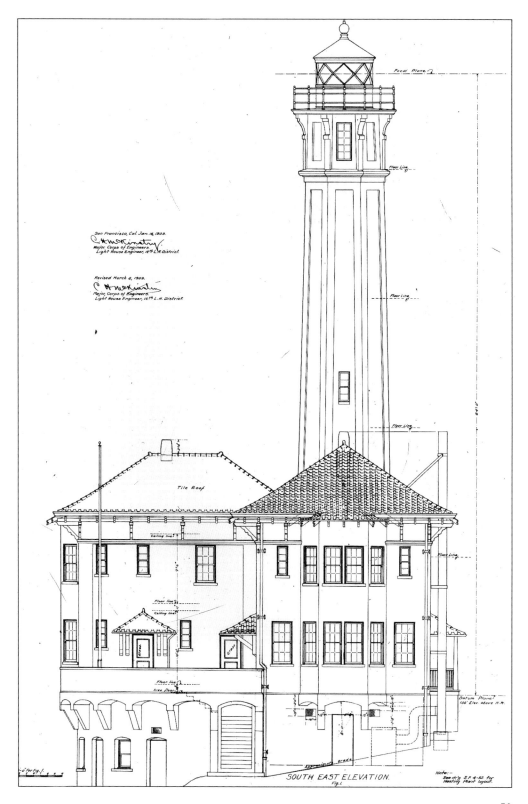

San Francisco, Cal. Jan. 18, 1909.

C. H. McKinstry
Major, Corps of Engineers.
Light House Engineer, 12th L.H. District.

Revised March 6, 1909.

C. H. McKinstry
Major, Corps of Engineers.
Light House Engineer, 12th L.H. District.

Focal Plane

Floor Line

Floor Line

Floor Line

Tile Roof

Ceiling Line

Floor Line
Ceiling Line

Floor Line

Floor line
Area Plane

Floor Line

Datum Plane
130' Elev. above H.W.

SOUTH EAST ELEVATION.
Fig. 1.

Note:—
See dr'g S.F. 4-52 for
Heating Plant layout.

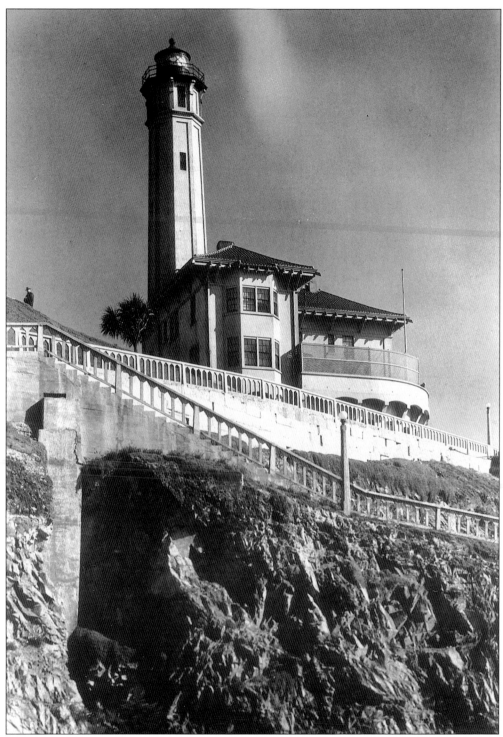

The new Alcatraz Light Station, consisting of a tower, keeper's dwelling (left), and duplex for the assistants (right).

THE ORIGINAL FOG SIGNALS ON ALCATRAZ ISLAND—TWO BELL FOG SIGNALS, ONE ON THE NORTH SIDE AND ONE ON THE SOUTH SIDE. Above is the south bell house with a weight tower behind the building. The 4,000-pound bell is suspended on a porch below.

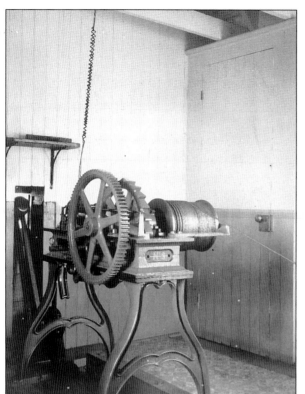

**A Stevenson automatic bell striker in the bell house.** As the weights descended, gears moved. When a cam dictated, a sledge hammer was sprung through a hole in the wall, striking the bell outside on the porch.

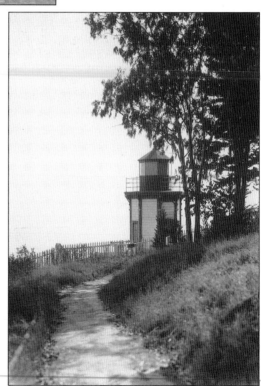

The Yerba Buena Island Light Station tower.

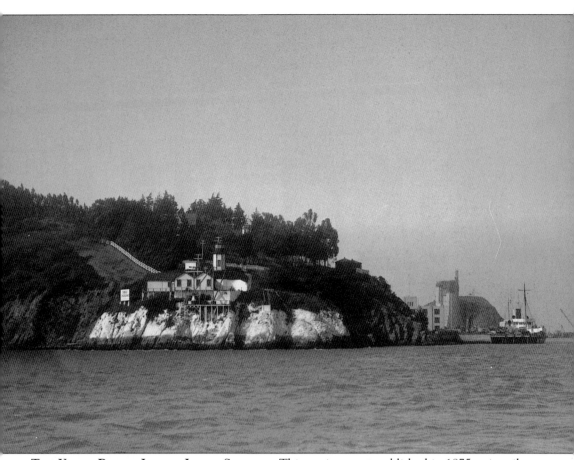

**THE YERBA BUENA ISLAND LIGHT STATION.** This station was established in 1875, primarily to guide ferries plying the bay between San Francisco and Oakland. The tower is visible above the fog signal buildings. At right is a Lighthouse Service tender moored at the Lighthouse Service Depot. In the background is a pier for the new San Francisco-Oakland Bay Bridge (under construction).

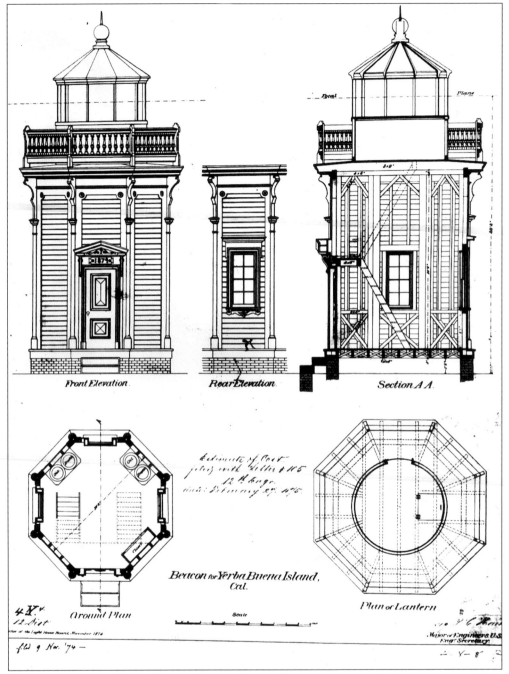

Front Elevation.

Rear Elevation.

Section A A.

Ground Plan

Plan of Lantern

Beacon for Yerba Buena Island, Cal.

Scale

THE PLANS OF THE YERBA BUENA ISLAND LIGHT STATION TOWER. Only two towers of this style were ever constructed. The other was located in New York at West Point on the Hudson River. It is now gone.

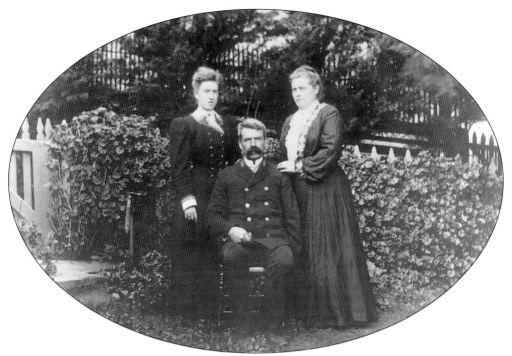

Yerba Buena Island Light Station assistant keeper John Kofod, his wife, Emma, and their daughter Anna, in the garden of the station, 1906.

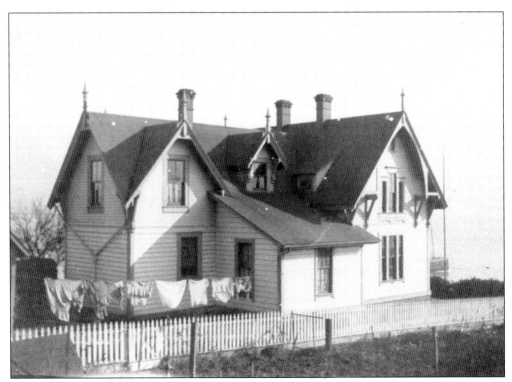

The keeper's duplex of Yerba Buena Island Light Station, 1908.

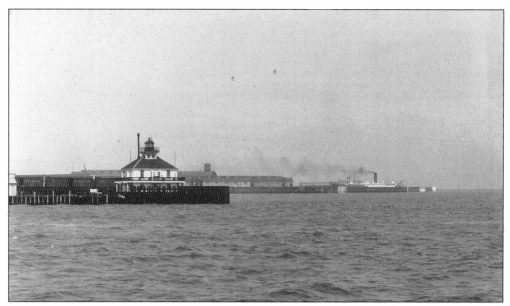

**THE OAKLAND HARBOR LIGHT STATION.** This station was established in 1890, but within a few years marine borers undermined the pilings. A new station (above) was constructed in 1903.

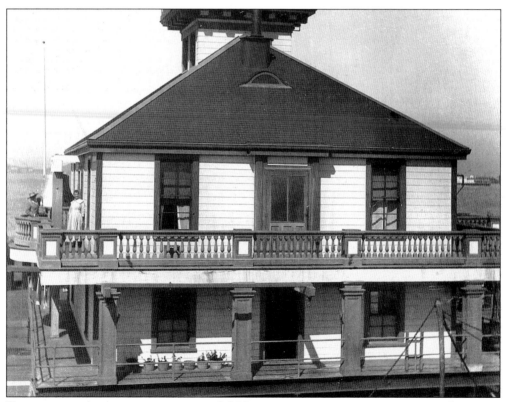

THE KEEPERS' WIVES BY THE 4,000-POUND FOG BELL AT THE OAKLAND HARBOR LIGHTHOUSE.

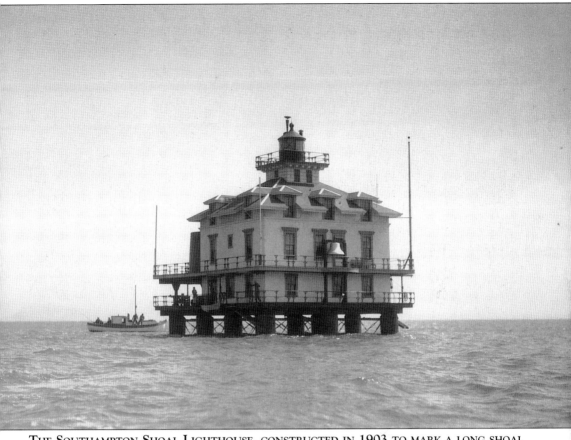

**THE SOUTHAMPTON SHOAL LIGHTHOUSE, CONSTRUCTED IN 1903 TO MARK A LONG SHOAL IN THE MIDDLE OF SAN FRANCISCO BAY.** Two keepers and their families lived in the two-and-a-half-story structure. In 1934, while the assistant keeper and his wife were ashore, the head keeper, Albert Joost, caught himself and the building on fire while removing paint with a blow torch. He and his wife managed to douse the flames, but keeper Joost was badly burned. Leaving his wife to light the lens that evening, he took the station boat to nearby Angel Island. People on the island took him to a hospital in San Francisco, where he died from his burns three days later.

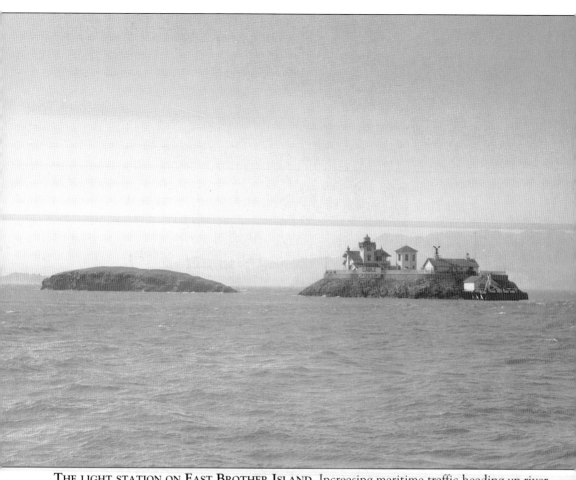

**THE LIGHT STATION ON EAST BROTHER ISLAND.** Increasing maritime traffic heading up river to the ports of Sacramento and Stockton prompted the Lighthouse Service to construct a light station on East Brother Island in 1874. The island and its twin, West Brother, are located at the confluence of San Francisco and San Pablo Bays.

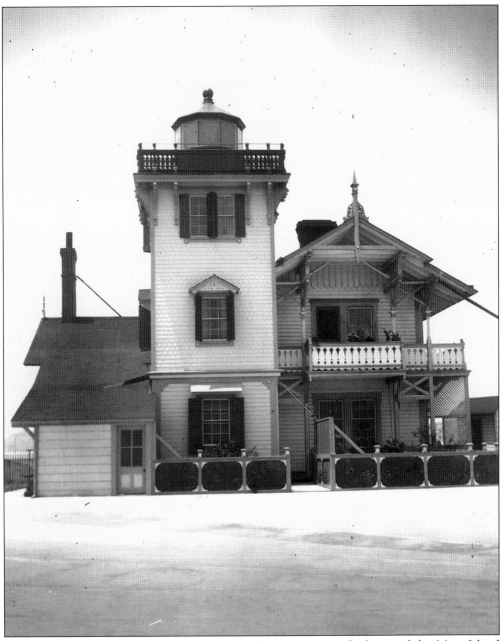

**THE EAST BROTHER ISLAND LIGHTHOUSE.** This tower was a duplicate of the Mare Island Station, which was located at the north end of San Pablo Bay. Both were constructed of redwood in the Victorian Eastlake style. The area in front of this duplex dwelling is a concrete rain catchment basin.

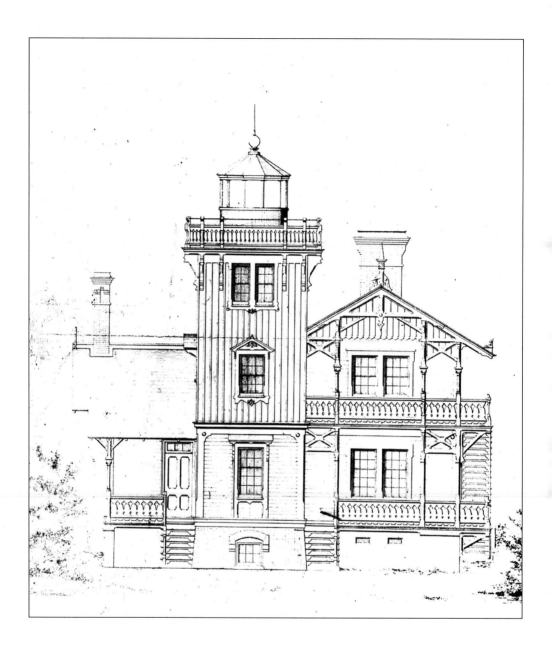

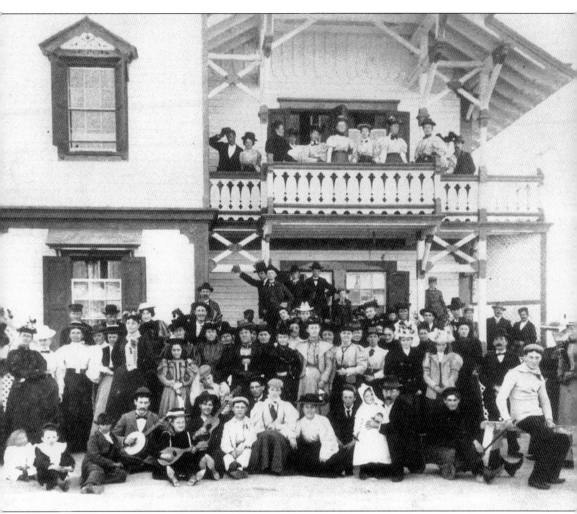

**HURRAH!** The gang's all here. Party time at the East Brother Lighthouse, *c.* 1890.

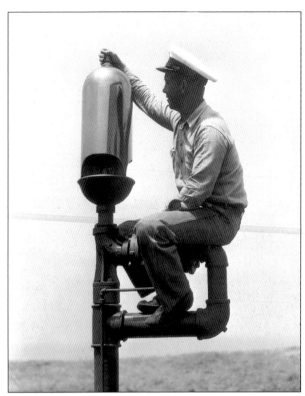

A KEEPER POLISHING
THE FIRST-CLASS STEAM
WHISTLE FOG SIGNAL.

THE FIRST FOG SIGNAL BUILDING
ON EAST BROTHER ISLAND. The
steam-powered whistle can be seen
just left of smoke stack. In later
years the whistle was replaced
by an air-powered diaphone that
produced a two-tone ("beee-
ooooh") sound.

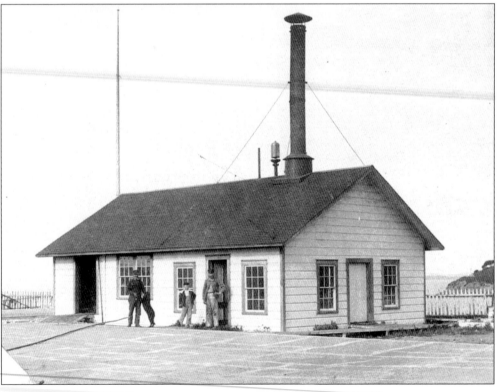

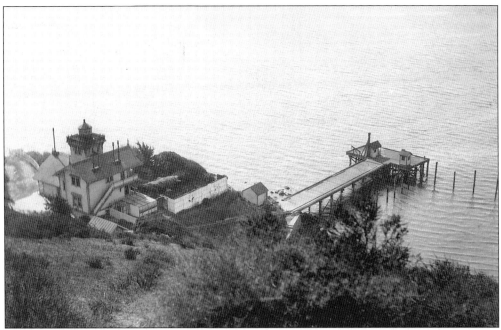

**LOOKING DOWN ON THE MARE ISLAND LIGHT STATION, A TWIN TO THE EAST BROTHER STATION.** This station served from 1873 to 1917, when it was abandoned. The structure was razed sometime in the 1930s.

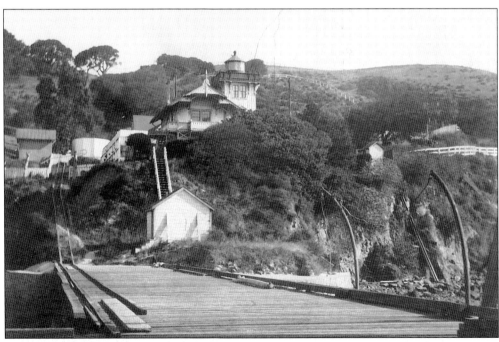

**A VIEW OF THE STATION FROM THE DOCK.** Kate McDougal was the keeper of this station for many years. Her husband, Commander Charles McDougal, was the navy inspector in charge of California lighthouses until he drowned going ashore at Cape Mendocino. She was subsequently offered the keeper's position.

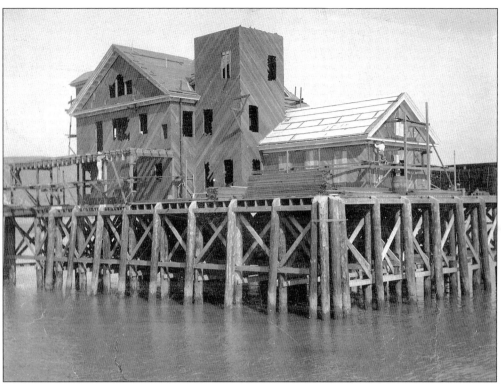

THE CARQUINEZ LIGHT STATION. Large vessels navigating through narrow Carquinez Strait necessitated the Lighthouse Service to begin construction of this lighthouse in 1909.

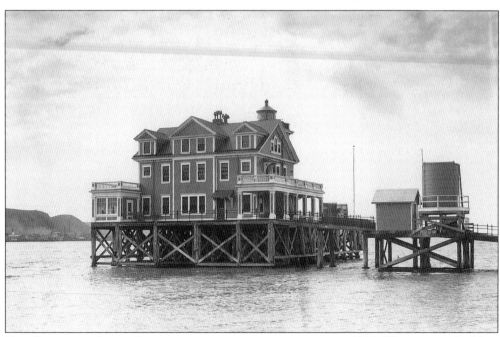

THE CARQUINEZ LIGHT STATION, WHICH WAS OPERATIONAL BY 1910. This massive building housed four keepers and their families.

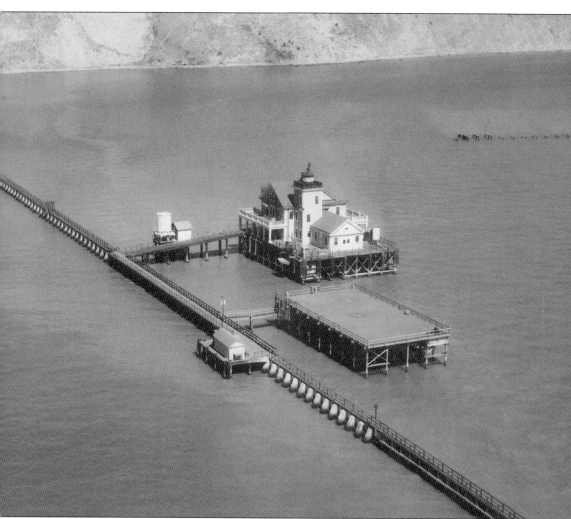

THE CARQUINEZ LIGHT STATION, LOCATED AT THE END OF A 900-YARD-LONG PIER. The platform in the foreground was a wharf where the Lighthouse Service tender landed supplies. The dwelling was sold by the government in the 1960s and moved to nearby Elliot Cove to serve as offices for a yacht harbor. (Courtesy U.S. Coast Guard.)

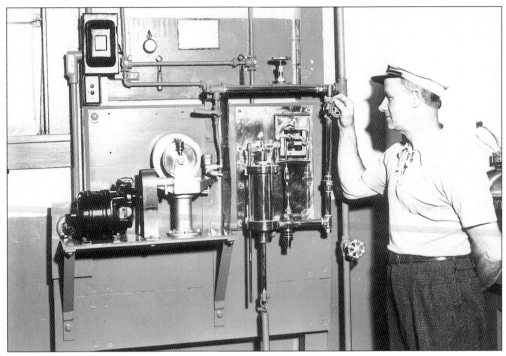

THE CARQUINEZ LIGHTHOUSE KEEPER AT THE CONTROLS FOR THE FOG SIGNAL.

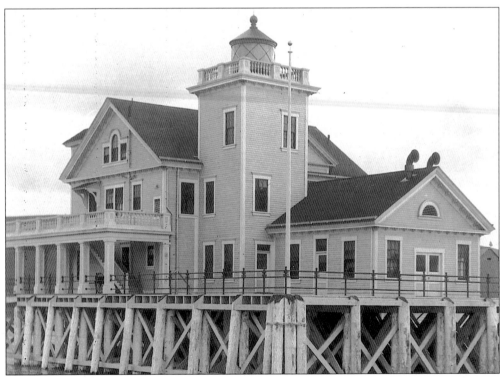

THE FOG SIGNAL HORNS (ON THE ROOF AT RIGHT). When the Carquinez Strait Bridge was constructed in 1930, the fog signal was discontinued.

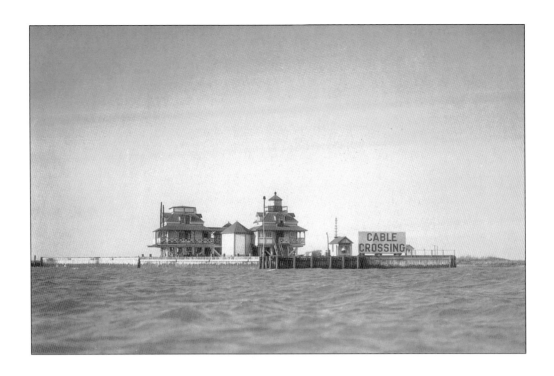

**TWO VIEWS OF THE ROE ISLAND LIGHT STATION, CONSTRUCTED ON A LOW, MARSHY ISLAND IN SUISUN BAY.** The top view shows two dwellings with a water tank between them and a bell fog signal house at right. During WW II an ammunition ship blew up at Port Chicago, one mile across the bay. The shock waves damaged the station to such a great extent that it was razed.

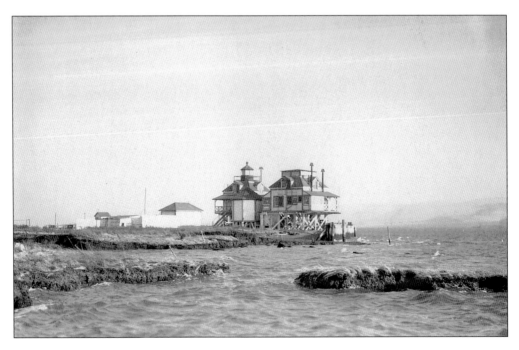

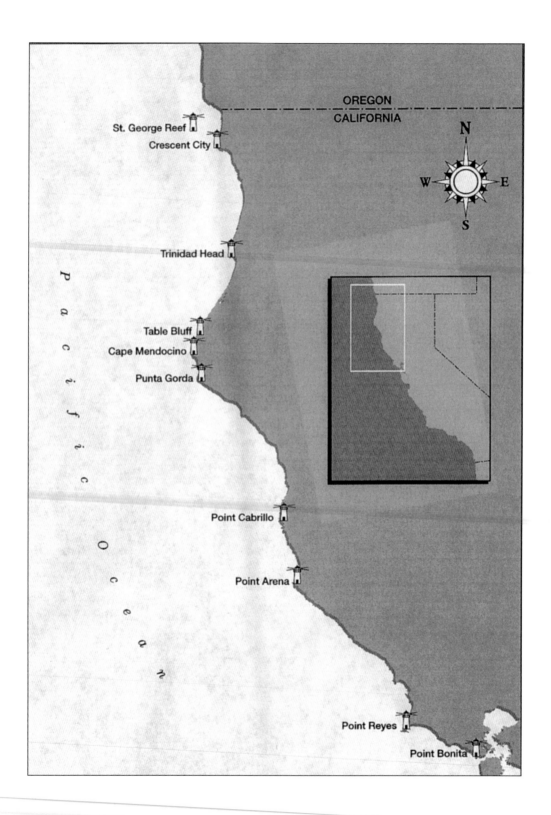

OREGON
CALIFORNIA

N
W E
S

St. George Reef
Crescent City

Trinidad Head

*P a c i f i c*

Table Bluff
Cape Mendocino
Punta Gorda

Point Cabrillo

Point Arena

*O c e a n*

Point Reyes
Point Bonita

# Three

# THE NORTH COAST

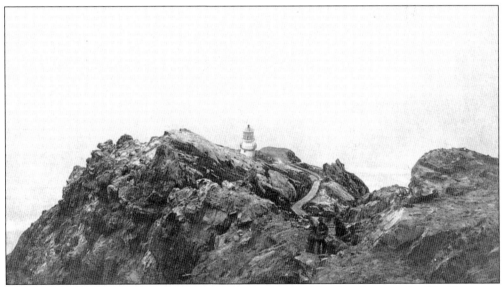

**THE FIRST-ORDER LIGHTHOUSE AT POINT REYES.** Much of the shoreline north of San Francisco is known as the Redwood Coast. In the years after the Gold Rush the redwood lumber of this area was harvested and brought to the growing San Francisco Bay area region. Lighthouses and other aids to navigation were established to guide the coastal steamers plying the rocky and fog-shrouded waters north of San Francisco. Like the rest of the West Coast, prevailing currents and winds tend to set mariners on a lee shore.

One of the few light stations established in California during the 1860s was constructed at Point Reyes in 1869. Although Congress authorized this station years before, the Civil War delayed construction.

The point was named by the Manila ships, Spanish galleons that sailed between Mexico and Manila in the 1500s. Their northerly return route from the Philippines caused most to make landfall at what they named Point Reyes. Upon reaching this narrow finger of land, the vessels would alter course south to Mexico. Some of the vessels made this landfall in darkness or fog and came to grief on the rocky shore, which became known as the "Graveyard of the Pacific."

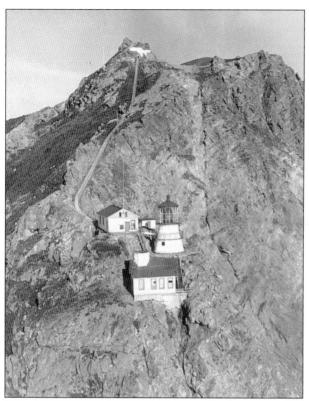

THE POINT REYES LIGHT STATION DWELLING AT TOP OF CLIFF, THE LIGHTHOUSE TOWER, AND THE THIRD FOG SIGNAL BUILDING (OF THREE) AT THE BOTTOM OF A 320-STEP STAIRCASE. (Courtesy U.S. Coast Guard.)

THE LIGHT STATION, LOCATED AT THE EXTREME RIGHT OF THIS NARROW PENINSULA. (Courtesy U.S. Coast Guard.)

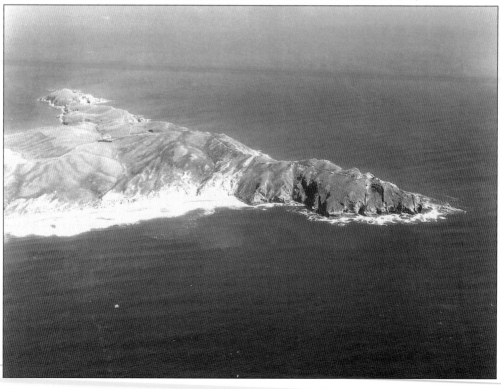

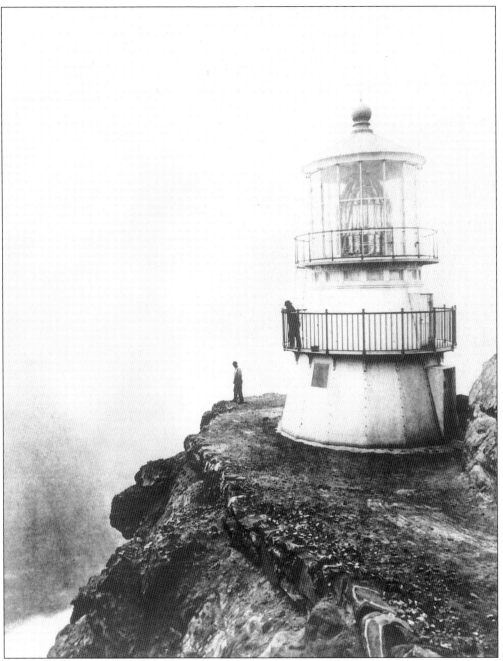

A C. 1880 PHOTO OF THE 16-SIDED CAST-IRON TOWER, SHOWING THE FIRST-ORDER FRESNEL LENS IN THE LANTERN ROOM. Only two towers of this design were constructed; the other is at Cape Mendocino, farther north on the California Coast.

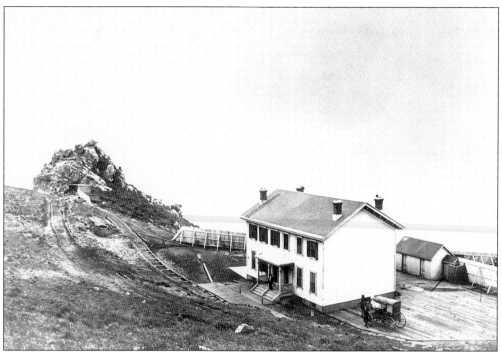

**THE ASSISTANT KEEPER'S DUPLEX.** Note the railway running in front of the dwelling to the cliff edge, where it starts down to the fog signal building and tower.

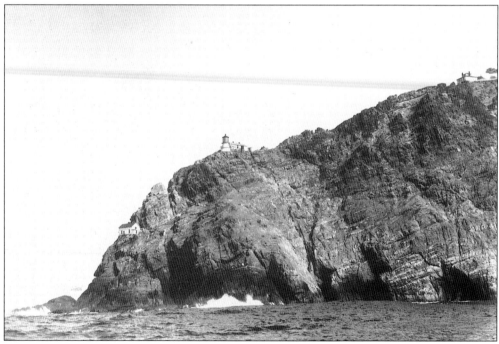

**THE FIRST FOG SIGNAL BUILDING (AT EXTREME LEFT).** This structure was difficult to access and burned down twice. Eventually a new fog signal building was constructed beside the tower. The assistant keepers' dwelling can be seen at top right.

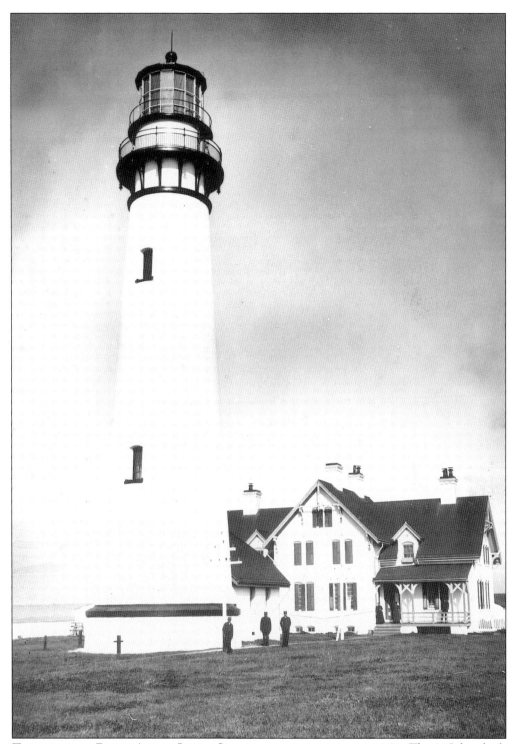

**THE ORIGINAL POINT ARENA LIGHT STATION, CONSTRUCTED IN 1870.** The 115-foot-high light tower was located next to the dwelling, a brick four-plex. Both were destroyed by the 1906 earthquake. (Courtesy National Maritime Museum.)

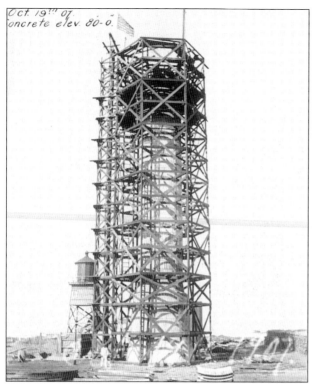

Oct. 19.th 07.
concrete elev. 80-0.

**THE 115-FOOT-HIGH REPLACEMENT TOWER AT POINT ARENA.** This tower, the first of its type in America, was constructed by a San Francisco chimney company out of reinforced concrete. A temporary wooden tower with a lantern room can be seen at left. Note the American flag flying from the top of the scaffolding.

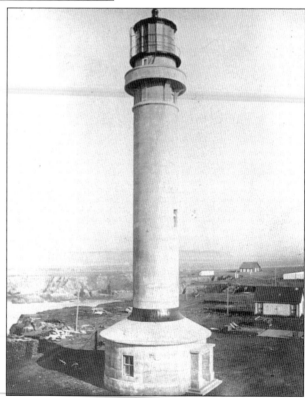

**THE COMPLETED POINT ARENA LIGHT TOWER PRIOR TO PAINTING IN 1908.** The round area at its bottom was constructed to help resist future earthquakes.

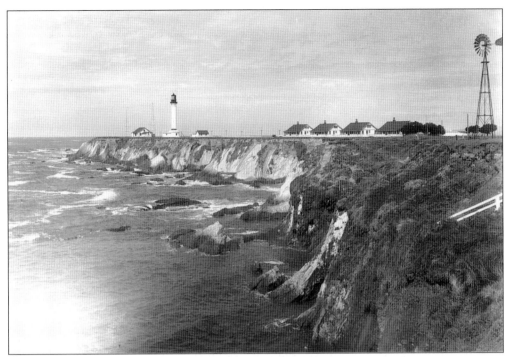

**THE REBUILT POINT ARENA LIGHT STATION.** From left to right are the wooden fog signal building (which survived the earthquake), the new tower, four new bungalows (which replaced the four-plex dwelling), and a windmill to pump water.

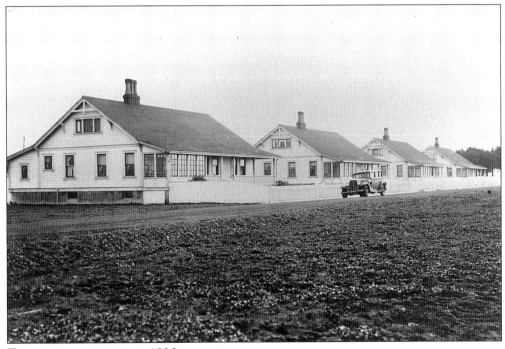

**THE NEW BUNGALOWS, C. 1930.**

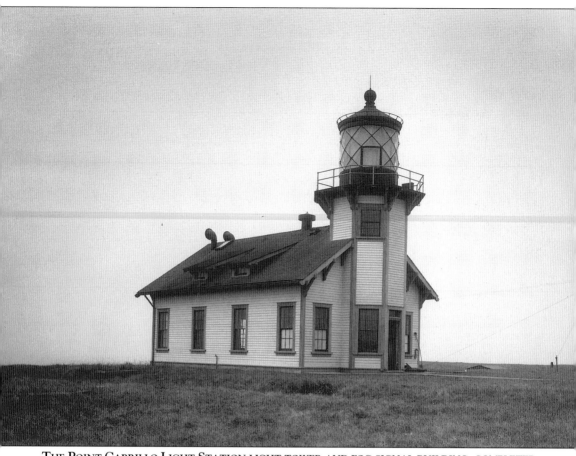

**THE POINT CABRILLO LIGHT STATION LIGHT TOWER AND FOG SIGNAL BUILDING, COMPLETED IN 1909.** Note the diagonal astragals of the lantern (astragals are the bars which hold the panes of glass in place). This is a typical English design, rare in this country and usually not used before 1903. The fog signal trumpets can be seen at the left edge of the roof.

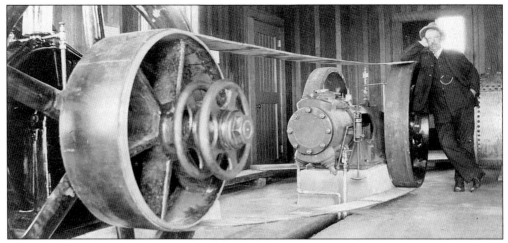

AN AIR COMPRESSOR FOR THE FOG SIGNAL.

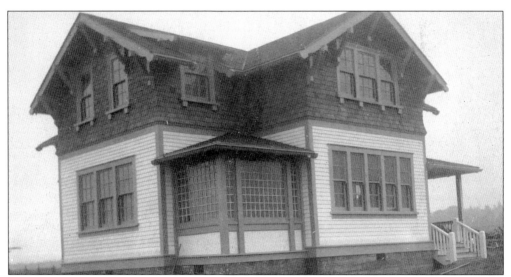

THE PRINCIPAL KEEPER'S DWELLING.

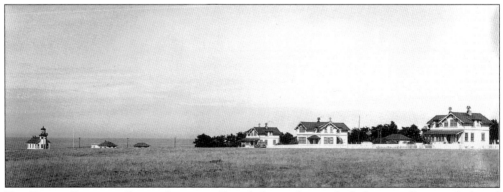

THE POINT CABRILLO LIGHT STATION. From left to right are the light tower/fog signal, the oil house, the blacksmith shop, and the three dwellings.

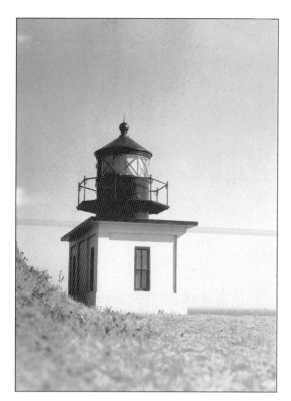

**THE PUNTA GORDA LIGHT STATION, CONSTRUCTED IN 1911 ON A REMOTE BEACH FAR FROM CIVILIZATION.** The tower is visible in the bottom photograph to the left of the far dwelling. The fog signal building can also be seen at the extreme left.

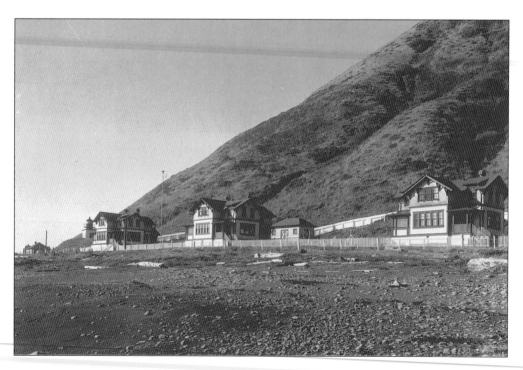

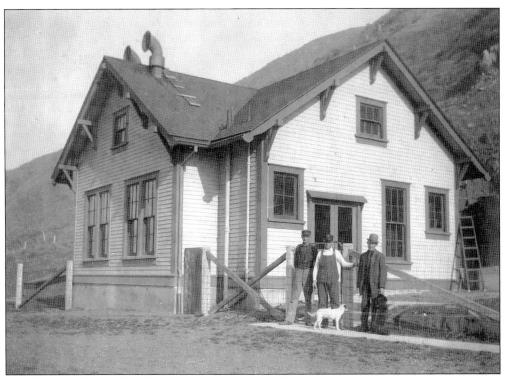

THREE KEEPERS AT THE FOG SIGNAL BUILDING.

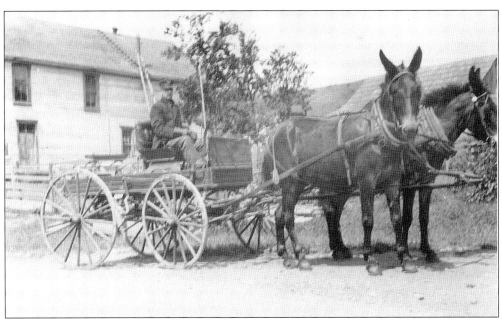

THE STATION WAGON AND MULES. The road to and from the station was very rough. Reaching the main highway was an arduous, two-hour trip, requiring the fording of a stream (which was impossible during heavy rains). The only neighbors were a few farmers. A trip to town, probably Ferndale, was a long haul, usually requiring the keeper to stay overnight.

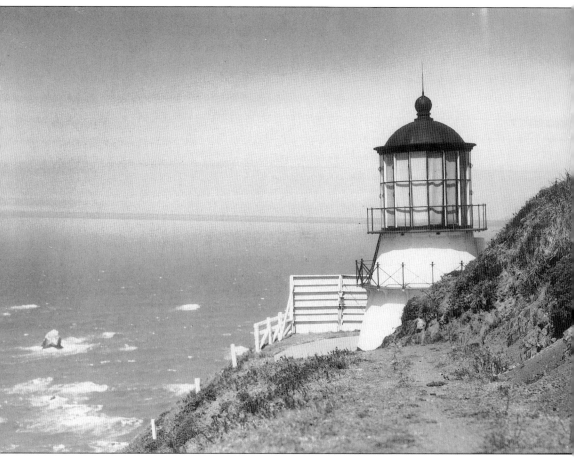

**THE CAPE MENDOCINO LIGHT STATION TOWER, ESTABLISHED IN 1868.** This station, a duplicate of that at Point Reyes, is one of the highest in America, at 422 feet above sea level. The tower contained a first-order Fresnel lens. The fence next to the tower is to protect the keepers from blowing over the cliff.

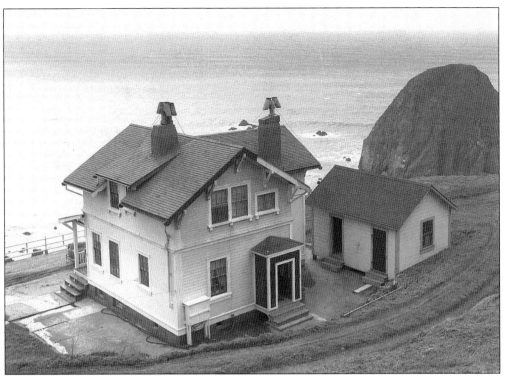

**THE ASSISTANT KEEPERS' DUPLEX.** The mound at right is a large off-shore formation known as "Sugarloaf." (Courtesy U.S. Coast Guard.)

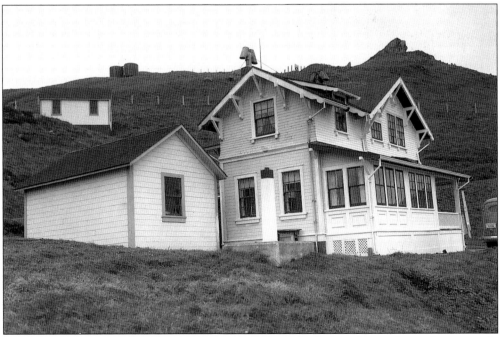

**THE KEEPER'S HOUSE.** All buildings of this station were rebuilt several times due to the extremely strong winds that buffet the area most of the year. (Courtesy U.S. Coast Guard.)

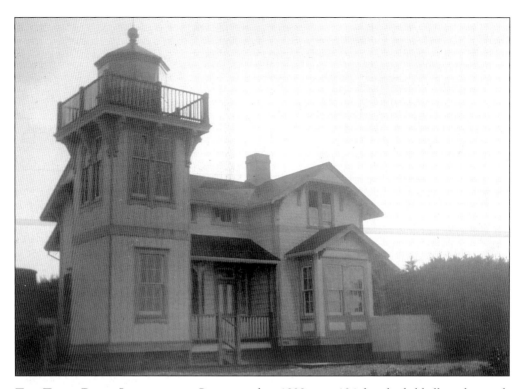

**THE TABLE BLUFF LIGHTHOUSE.** Constructed in 1892 on a 124-foot-high bluff on the south side of the entrance to Humboldt Bay, this tower replaced the old Humboldt Bay Lighthouse, which was located on the north side of the entrance. The old station was too low to effectively cast its beam over the horizon. The new station is a duplicate of those established at Ballast Point, San Diego, and San Luis Obispo, CA. During the 1920s and '30s many California stations had quaint entrance gates, and Table Bluff was no exception (as seen below). The assistant's duplex is visible to the left in the photograph below.

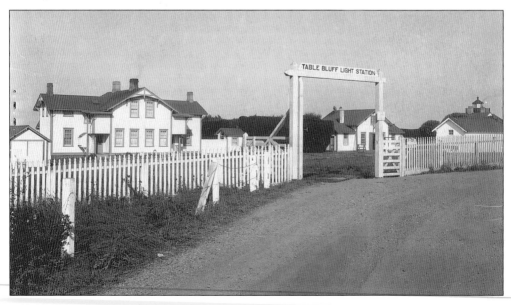

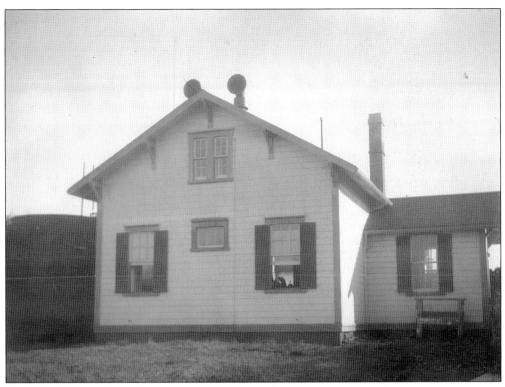

THE TABLE BLUFF FOG SIGNAL BUILDING.

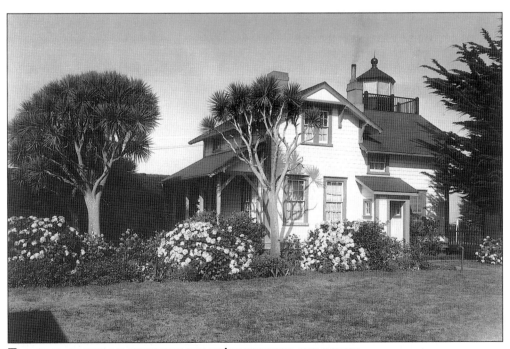

THE REAR OF THE COMBINATION KEEPER'S DWELLING AND TOWER.

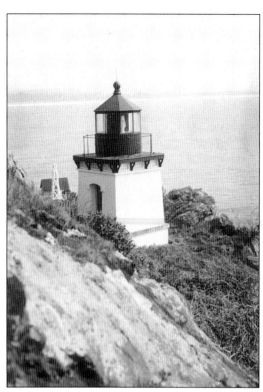

**THE TRINIDAD HEAD LIGHTHOUSE.**
Despite being located atop a sheer cliff,
196 feet above sea level, waves engulfed
this tower during a strong storm coming
in from the northwest. In the upper photo
you can see the bell fog signal building,
just left of the tower.

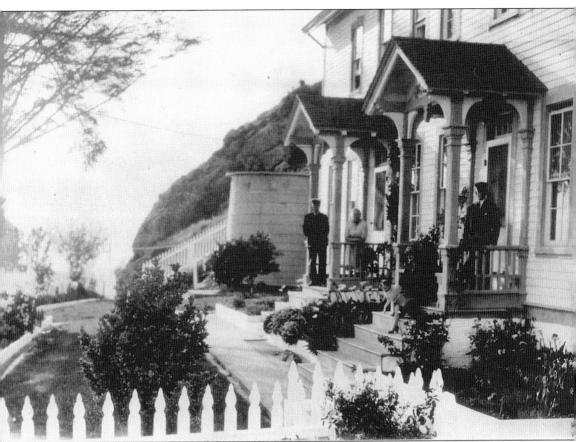

**THE KEEPER'S DWELLING (AS A DUPLEX), ORIGINALLY A SINGLE-FAMILY RESIDENCE.** After the bell signal was installed it was decided that two keepers were necessary and the dwelling was converted into a duplex.

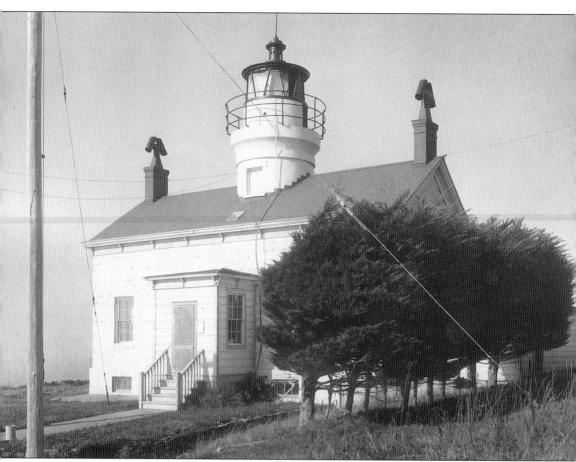

**CRESCENT CITY (BATTERY POINT) LIGHTHOUSE.** Completed in 1856, this was one of the second set of eight lighthouses authorized by Congress for the West Coast. It was actually finished before some of the first eight were completed.

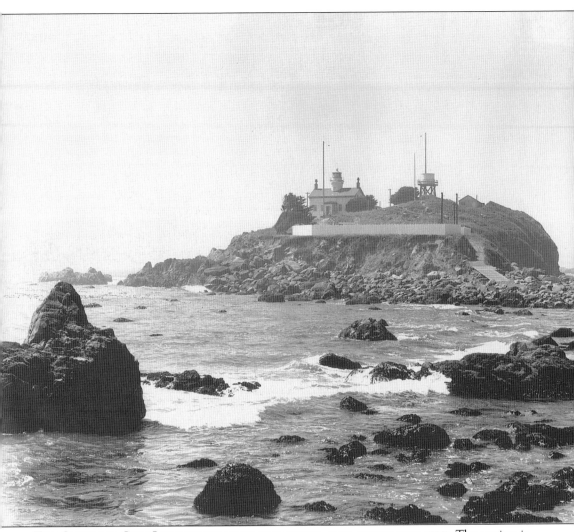

**THE CRESCENT CITY LIGHTHOUSE WITH THE WATER JUST ABOVE LOW TIDE.** The station is connected to the mainland by a tombolo, an isthmus that is inundated at high stages of tide. An access ramp can be seen at the right side of the island.

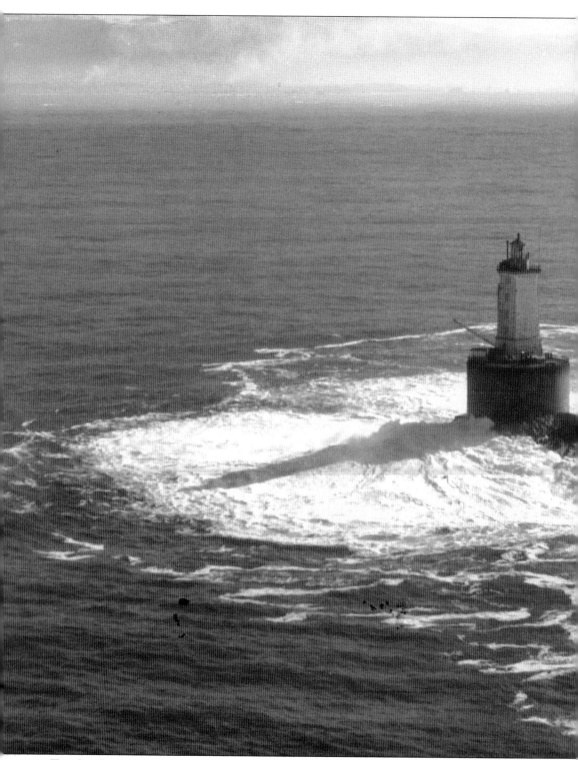

THE ST. GEORGE REEF LIGHTHOUSE, LOCATED 8 MILES OFFSHORE, NORTHWEST OF CRESCENT CITY, CA, NEAR THE OREGON BORDER. Its construction took ten years (1882–92) and it was

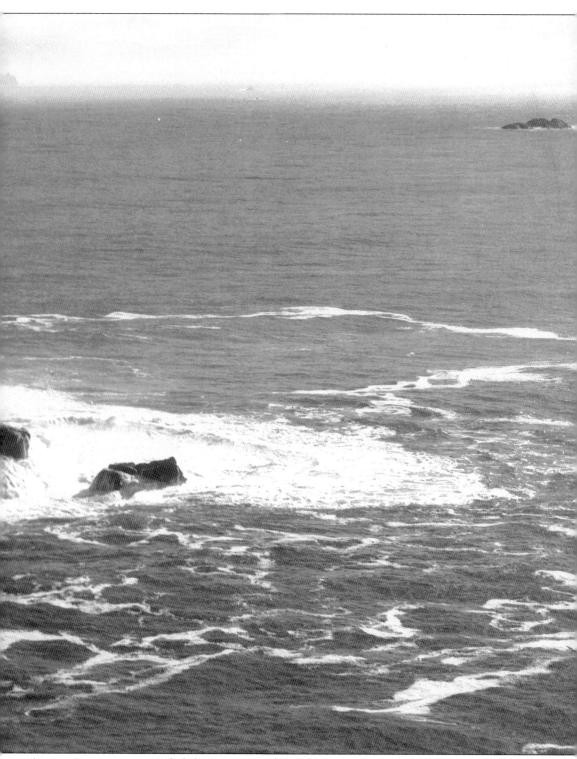

America's most expensive lighthouse, costing $715,000 (approximately $16 million in today's economy). (Courtesy U.S. Coast Guard.)

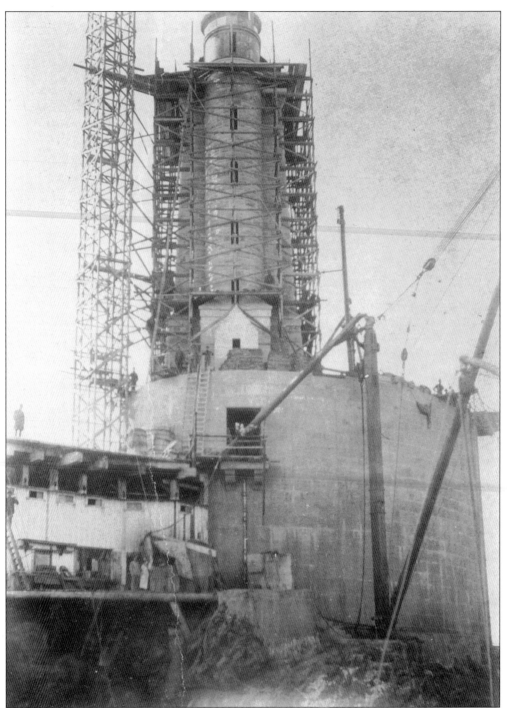

**THE CONSTRUCTION OF THE ST. GEORGE REEF LIGHTHOUSE.** It took nine years to prepare the site and construct the caisson. There are over 1,330 granite blocks in the exterior of the caisson alone, each weighing between 3 and 5 tons. The entire tower portion was constructed during the 1891 season. The first-order lens was installed in 1892, when the station became operational.

**WHISTLES AT ST. GEORGE REEF.**
The fog signals at St. George Reef
varied between whistles, sirens, and
diaphones.

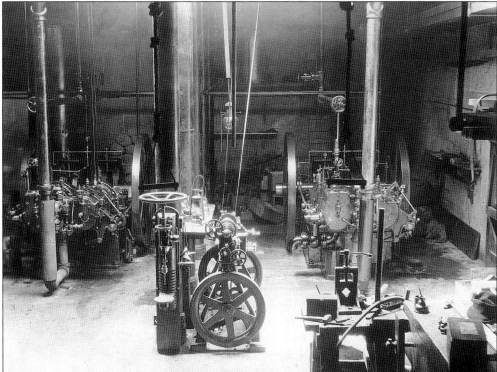

**THE ST. GEORGE REEF ENGINE ROOM.** Located in the caisson, the engine room housed air
compressors to power the fog horns, heating boilers, and machinery to generate electricity.

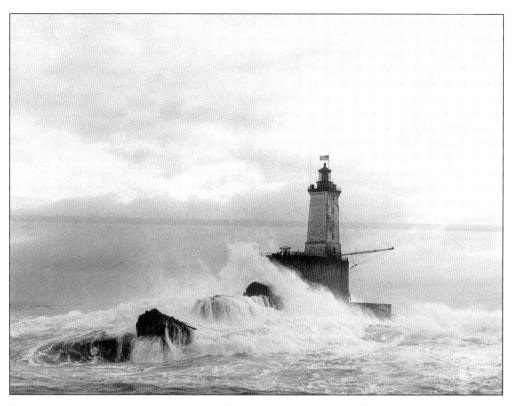

**The seas around the St. George Reef Light Station.** They are rarely as calm as depicted below in 1931. More often they resemble the above photo, taken in 1963. (Courtesy U.S. Coast Guard.)

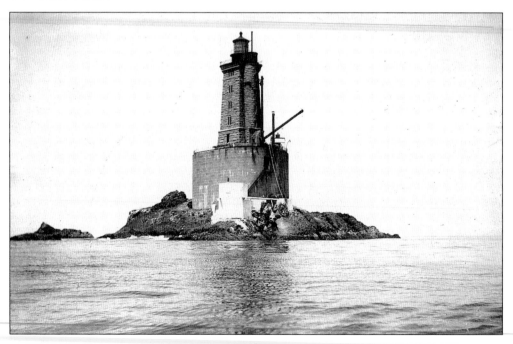

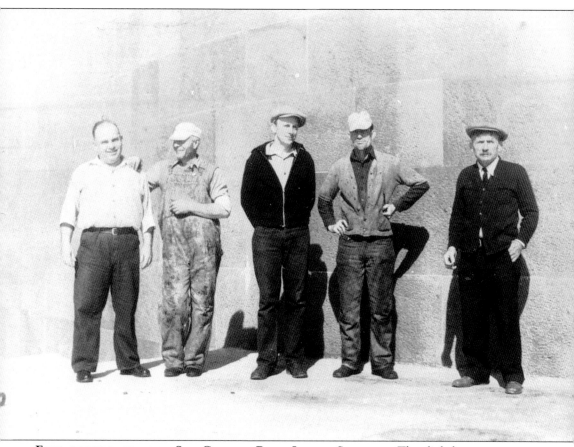

**Five keepers of the St. George Reef Light Station.** The lighthouse was an "unaccompanied station" where dependent families lived ashore. Four keepers remained on watch while the fifth was ashore.

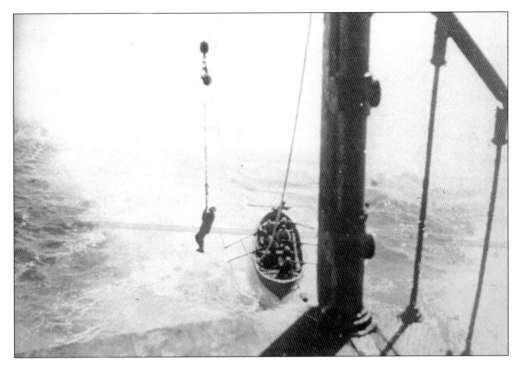

**Going ashore and returning for duty, hazardous operations even in the best of sea conditions.** A relief keeper is being hauled aboard in the above photograph.

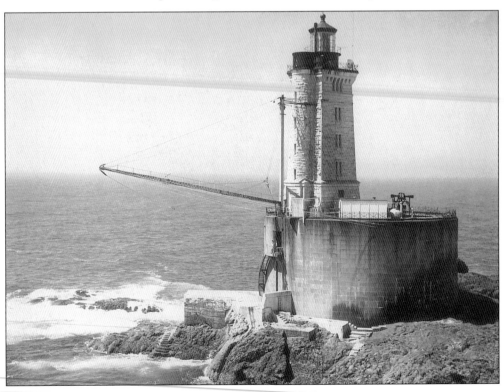

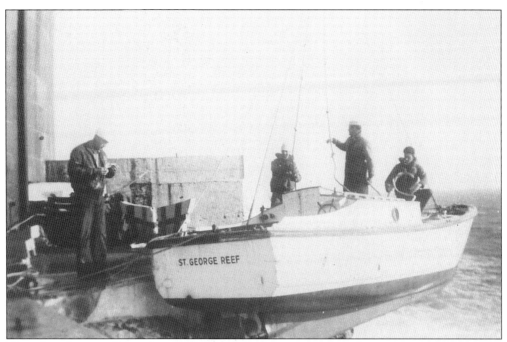

Two St. George Reef Coast Guard keepers and three Coast Guard repairmen preparing to go ashore in the station boat in April 1951.

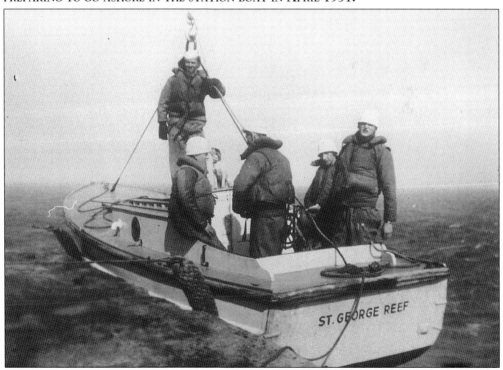

**THE BOAT BEING LOWERED.** One minute after this photo was taken, the forward bit holding the lowering line (rope) parted, throwing all five men in the water; three drowned. (Courtesy U.S. Coast Guard.)

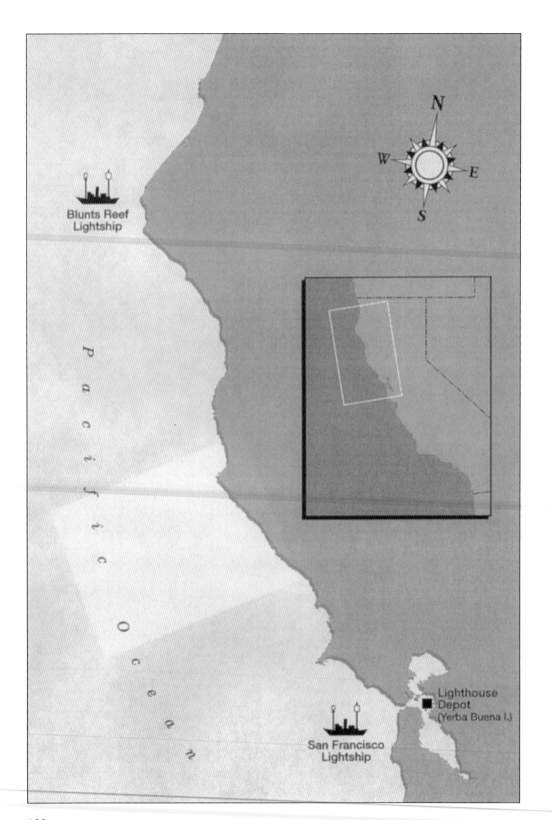

Blunts Reef
Lightship

N
W        E
S

Pacific Ocean

San Francisco
Lightship

Lighthouse
Depot
(Yerba Buena I.)

# *Four*

# THE LIGHTSHIPS

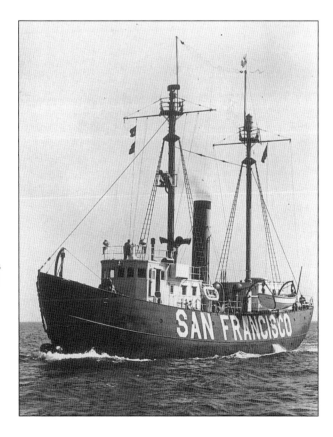

**A LIGHTSHIP OFF THE CALIFORNIA COAST.** There were two lightship stations on the California coast. The San Francisco Station lasted for 73 years (1898–1971). The Blunts (Reef) Station lasted for 66 years (1905–71). Over the years each station was occupied by different vessels. During the lightship years the district also had a relief vessel to spell the station vessel when she came in for shipyard work.

Lightships were established to either warn vessels of an obstruction, as was the case with the Blunts (Reef) Station, or to show vessels an entrance to a harbor (as the San Francisco Station did).

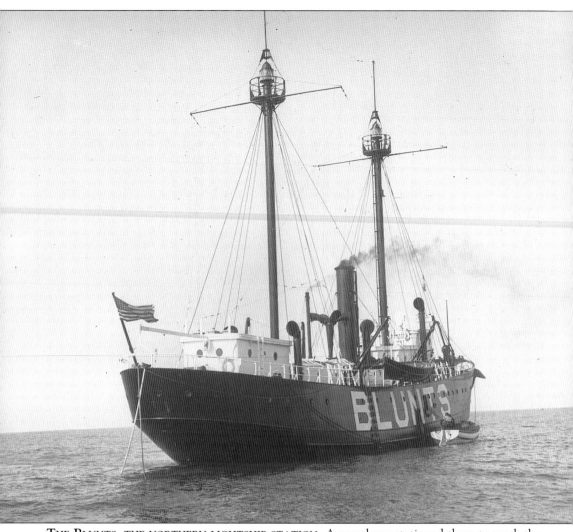

**THE BLUNTS, THE NORTHERN LIGHTSHIP STATION.** A vessel was stationed there to mark the Blunts Reef, a dangerous obstruction to navigation off Cape Mendocino and a major turning point for vessels engaged in the coastal trade. Four different ships served on this station over the years.

A SAILOR ABOARD THE SAN FRANCISCO STATION VESSEL *LV70*, CLIMBING THE MAST TO INSPECT THE 375MM OPTIC.

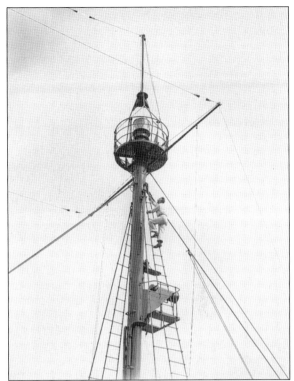

*LV70* SERVED THE SAN FRANCISCO STATION FROM ITS BEGINNING IN 1898 UNTIL 1930, WHEN SHE WAS REPLACED BY *LV83.* The purpose of this station was to mark the entrance to the San Francisco Bar Channel. The San Francisco pilot boats hove to near this station awaiting vessels about to enter San Francisco Bay. Two first-class steam-powered whistle fog signals can be seen to the left of the smoke stack.

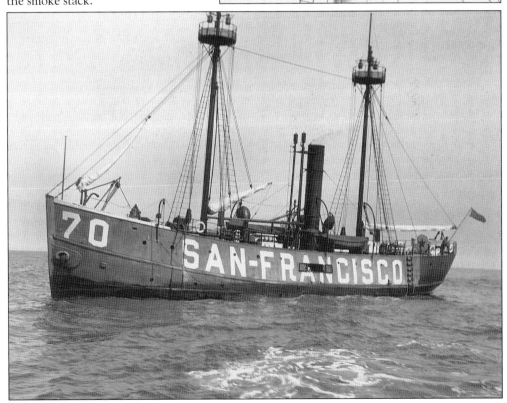

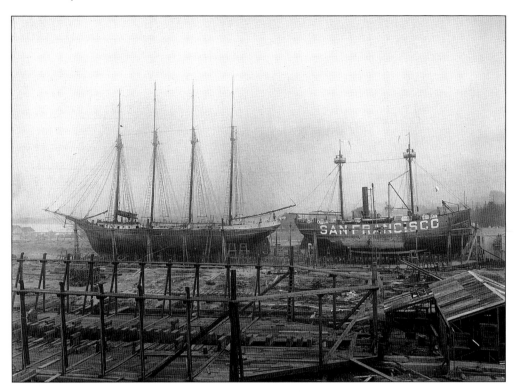

**CHANGING OF THE GUARD.** When the San Francisco lightship came in to be refurbished in dry-dock, a relief vessel, such as *LV92* (below), took the station and displayed the same light and fog signal characteristics until replaced by the primary vessel. *LV92* served as the 12th district relief vessel her entire career (1909–1951).

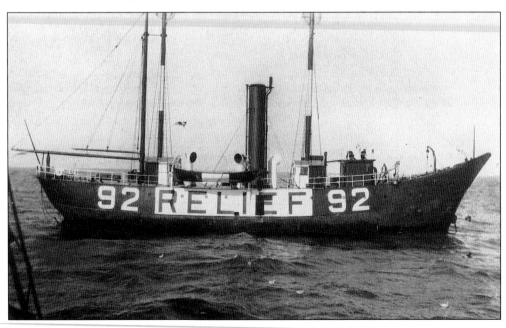

**ELEMENTS OF THE LIGHTSHIPS.**
Lightships had certain elements
which made them unique. At
right is a bell fog signal on
the bow of the San Francisco
lightship. If fog suddenly rolled
in, this bell was rung by hand
until a head of steam could be
raised to sound the whistle or
diaphone fog signal. The unique
6,000-pound mushroom anchor
in the photograph below was
peculiar only to lightships. The
anchor and its chain came from
the front of the ship's bow. On
almost all other ships the anchor
comes from the side of the bow.

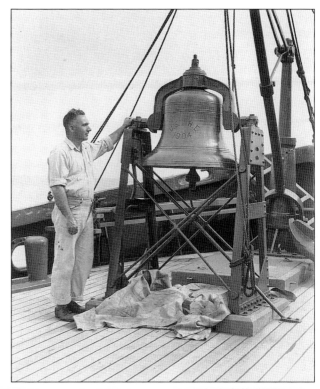

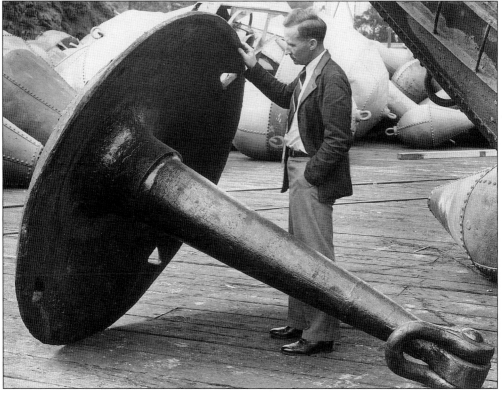

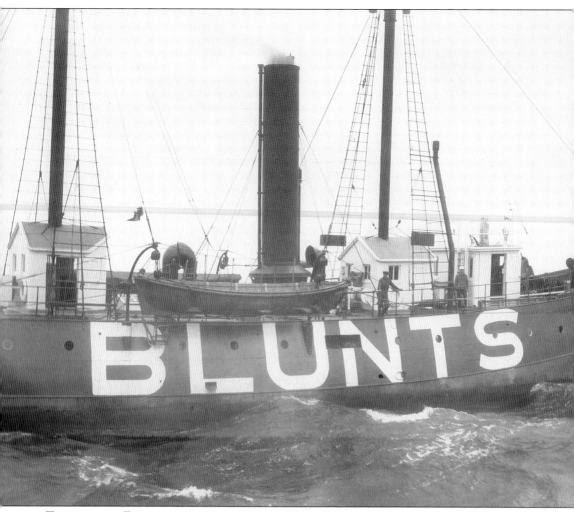

**THE CREW OF BLUNTS LIGHTSHIP AWAITING LINES THAT ARE ABOUT TO BE THROWN FROM THE SUPPLY TENDER.** District tenders visited the lightships periodically to swap crews and deliver mail, food, and supplies.

*Five*

# SUPPORT FACILITIES

**A U.S. LIGHTHOUSE SERVICE DEPOT.** Every lighthouse district had at least one depot. By 1930 the 12th district (California) had two, one at Long Beach and the other at Yerba Buena Island in San Francisco Bay. Depots had many functions. They stored supplies used by the light stations, lightships, and tenders. Buoys were refurbished at the depots, various chain components were fabricated, lenses were repaired, etc. Most depots also had a field construction force that built minor aids to navigation and made repairs at light stations.

THE NEWEST DEPOT IN CALIFORNIA, CONSTRUCTED AT LONG BEACH, C. 1930.

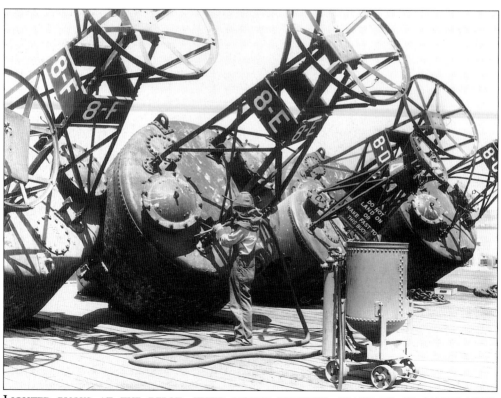

LIGHTED BUOYS AT THE DEPOT, THEIR LENSES REMOVED, READY TO BE SANDBLASTED AND REPAINTED.

A BLACKSMITH WORKING ON
BUOY MOORING CHAIN.

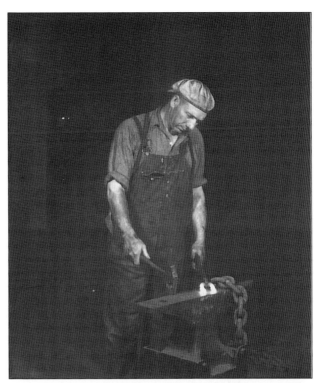

THE BLACKSMITH SHOP AT THE
YERBA BUENA ISLAND DEPOT.

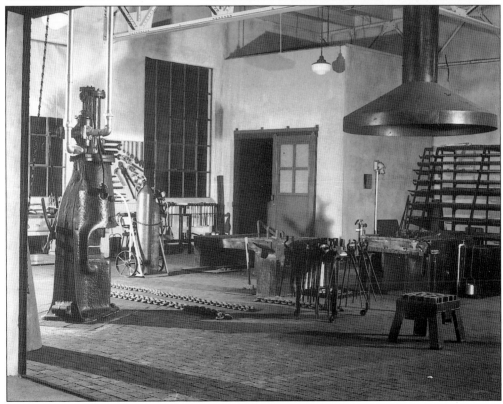

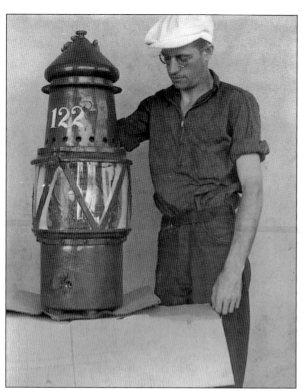

A DEPOT WORKMAN INSPECTING A 200-MM BUOY LANTERN.

THE LAMP SHOP AT THE DEPOT.

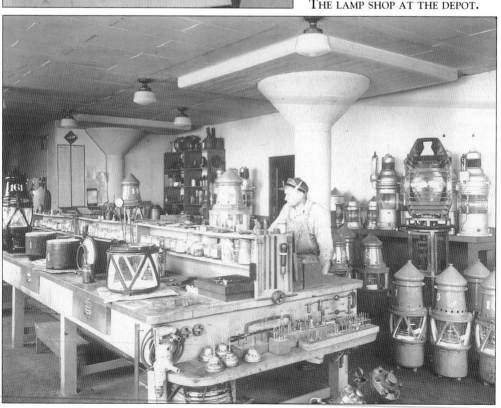

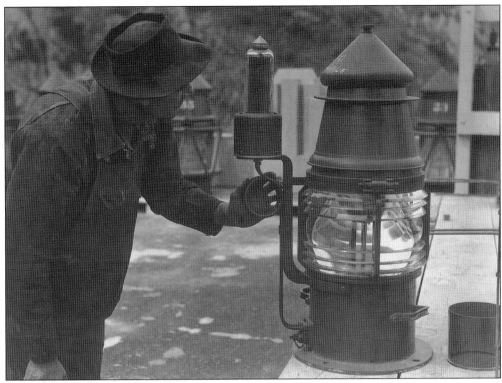

**A** DEPOT LENS TECHNICIAN CHECKING THE SUN RELAY OF AN ACETYLENE BUOY LENS. The sun relay caused the flow of gas to stop during daylight hours.

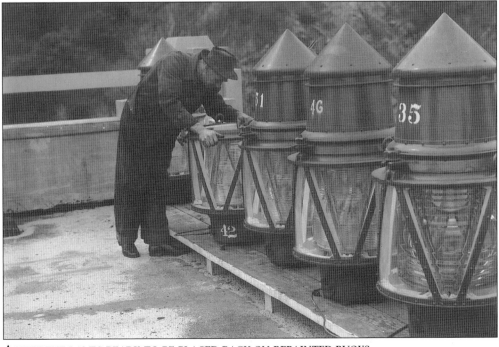

ACETYLENE LAMPS READY TO BE PLACED BACK ON REPAINTED BUOYS.

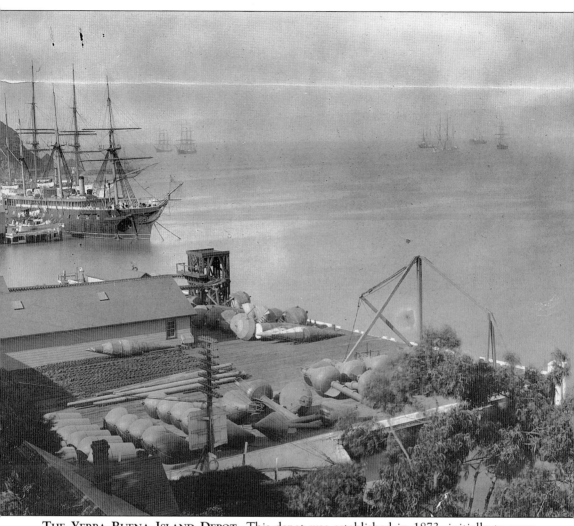

**THE YERBA BUENA ISLAND DEPOT.** This depot was established in 1873, initially to serve the entire West Coast, later just California. The island was originally named Goat Island. The photograph depicts, at left, the coal shed with a small tramway in front. Service tenders and lightships, when in port, would moor under this tramway, and small coal cars would move out over the open coal bins of the vessels and drop their loads into the ships' hold. In the foreground are various buoys waiting to be loaded on the buoy tenders. The sailing ship in the background is a navy ship tied up at the navy base on the western end of Yerba Buena (Goat) Island.

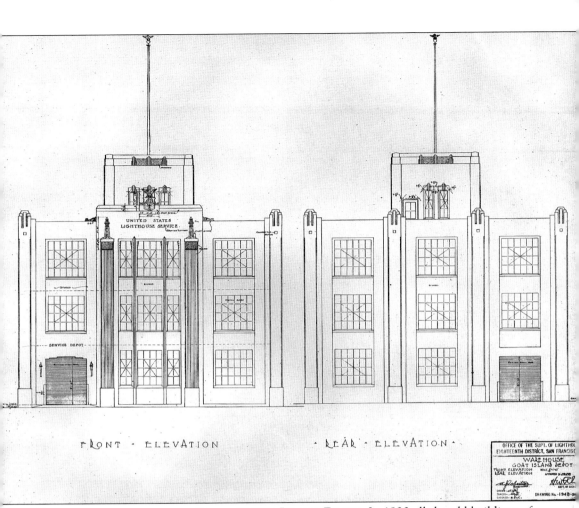

FRONT · ELEVATION                · REAR · ELEVATION ·

OFFICE OF THE SUPT. OF LIGHTHOU
EIGHTEENTH DISTRICT, SAN FRANCISC
WARE HOUSE
GOAT ISLAND DEPOT
FRONT ELEVATION    SCALE
REAL ELEVATION     APPROVED
DRAWN
TRACED
CHECKED    DRAWING No.-1948-3

**THE NEW BUILDINGS AT THE YERBA BUENA ISLAND DEPOT.** In 1930 all the old buildings of the Yerba Buena Island Depot were replaced with art deco-styled buildings.

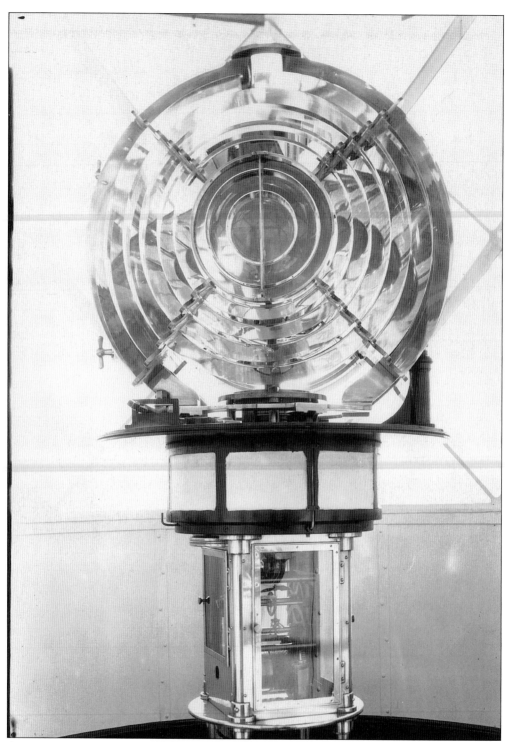

**A FOURTH-ORDER BIVALVE LENS.** Depots employed at least one district lampist, who was sent to light stations that were having problems with the mechanical portions of their rotating lenses, such as the one above.

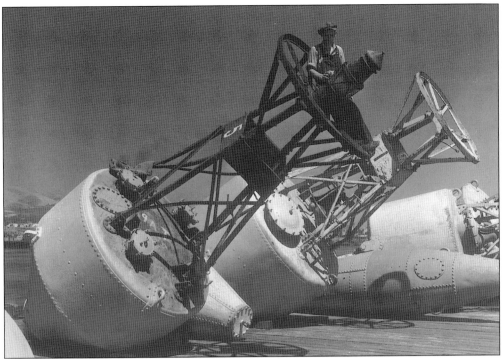

**A WORKMAN REINSTALLING A LANTERN ON A LIGHTED BUOY.** The next buoy is a bell buoy. Other sound buoys used by the service were gong and whistle buoys.

**A DEPOT WORKMAN CHIPPING PAINT FROM A BUOY PRIOR TO PAINTING IT.** Buoys typically stayed on station for six to seven years, then were replaced and brought in to be refurbished.

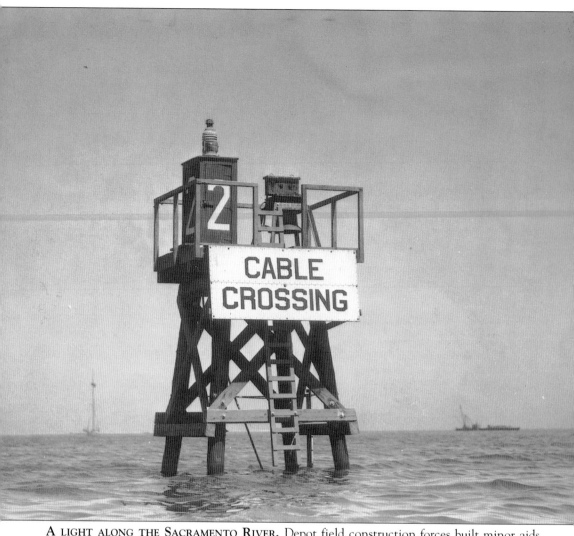

**A LIGHT ALONG THE SACRAMENTO RIVER.** Depot field construction forces built minor aids to navigation, including this light along the Sacramento River. In the 1930s these aids were powered by acetylene.

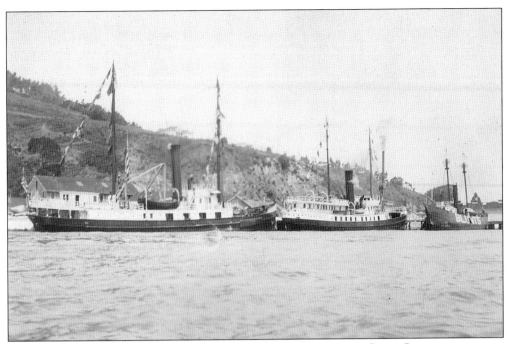

TENDERS SEQUOIA AND MADRONO AND LV83 MOORED AT THE GOAT ISLAND WHARF IN 1922. Depots served as home port for the district tenders.

A SMALL CRAFT TYPICAL OF THOSE USED TO CARRY SUPPLIES TO SAN FRANCISCO BAY LIGHTHOUSES. They also serviced minor, lighted aids to navigation and ferried personnel to and from San Francisco. This photo was taken in August 1935. The San Francisco-Oakland Bay Bridge is under construction in the background.

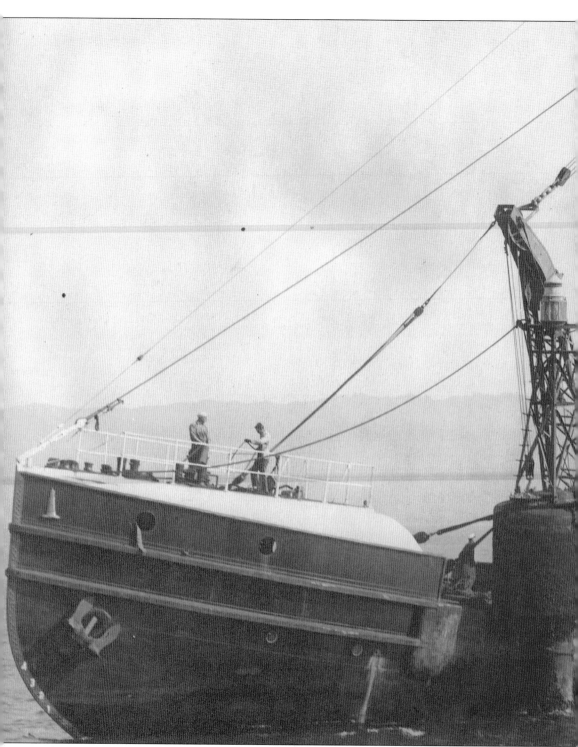

A 12TH DISTRICT TENDER, THE *SEQUOIA*, WORKING THE DUXBURY REEF LIGHTED BUOY IN NOVEMBER 1923. This particular buoy, 10 feet in diameter and 40 feet in length, was the largest used by the Lighthouse Service. Note the lighthouse bow ornament. The square device

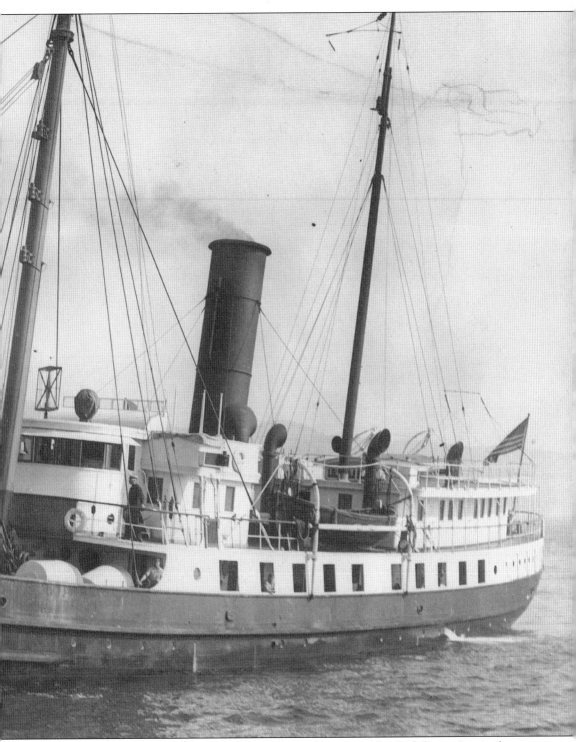

with a cross on the pilot house is an early radio beacon antenna. The Lighthouse Service began using radio beacons in 1923.

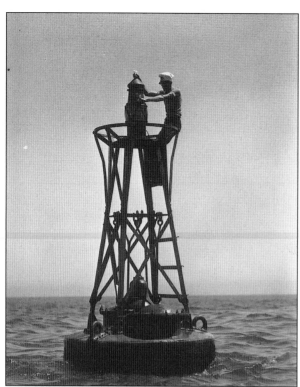

A SAILOR FROM THE TENDER *SEQUOIA* SERVICING THE LAMP OF A LIGHTED BELL BUOY.

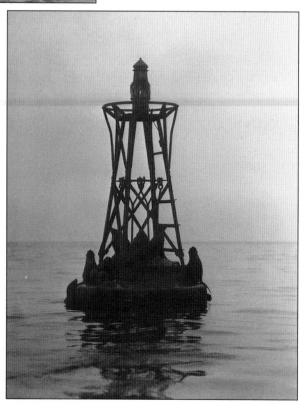

UNWANTED GUESTS BASKING IN THE SUN ON A BELL BUOY.

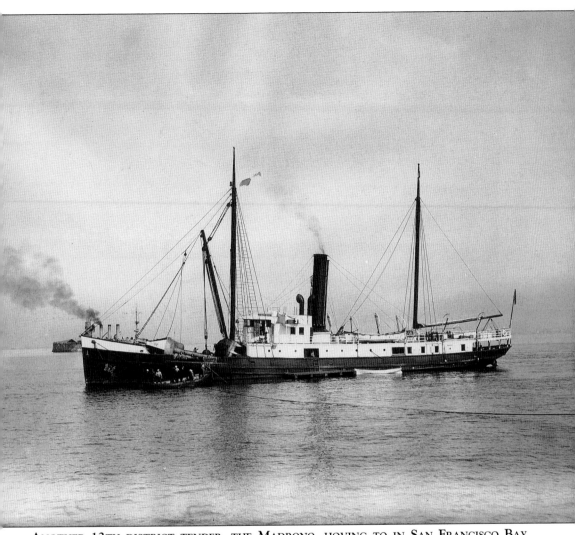

**ANOTHER 12TH DISTRICT TENDER, THE MADRONO, HOVING TO IN SAN FRANCISCO BAY WITH THE SHIP'S BOAT ALONGSIDE.** A portion of a battleship can be seen just past the bow.

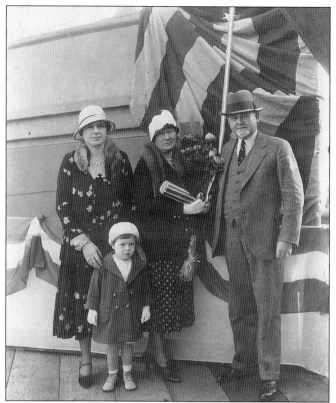

**THE COLUMBINE.** In 1930 the Lighthouse Service constructed a new tender for the California district. Tenders were usually named for flowers. The *Columbine* is shown below as she nears completion; in the photograph at left, District Superintendent Harry Rhodes, his wife, Harriet, their daughter Katherine, and her daughter Jane, prepare to christen the newly completed vessel. (Above courtesy of Skip Rhodes.)

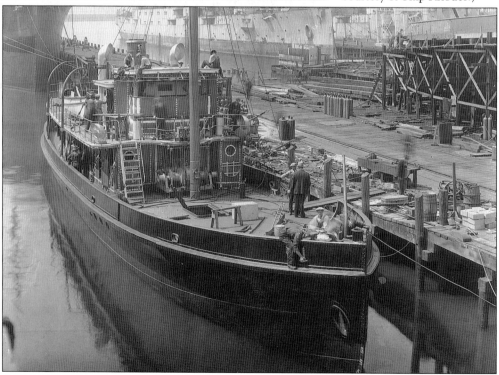

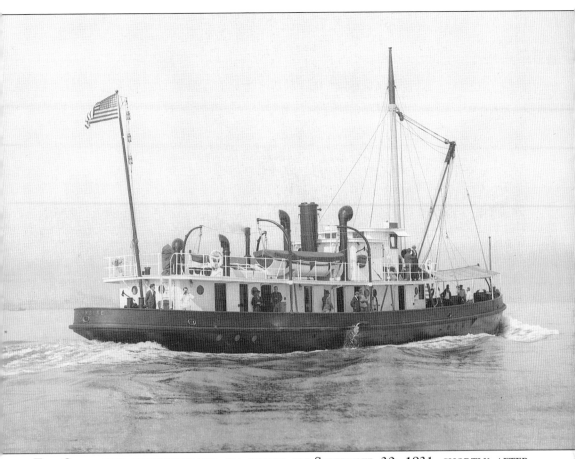

THE COLUMBINE UNDERWAY FOR SEA TRIALS ON SEPTEMBER 30, 1931, SHORTLY AFTER BEING LAUNCHED.

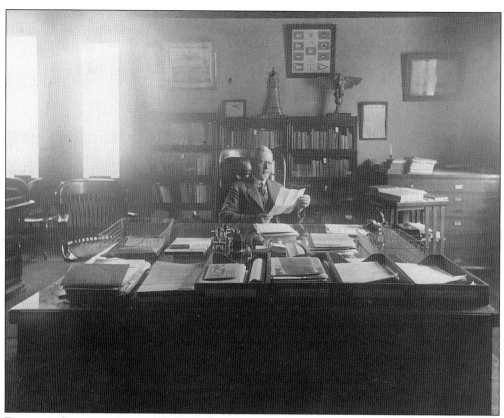

**District Superintendent Harry Rhodes examining papers at his desk in the San Francisco Custom House.** From 1852 to 1910, districts were presided over by naval officers, known as inspectors. In 1910 the federal government reorganized the Lighthouse Service, disbanded the military Lighthouse Board, and established the Bureau of Lighthouses with civilian inspectors to head each district. It took two years before all the new inspectors were in place. Harry Rhodes, who had worked for many years with the Coast and Geodetic Survey, was appointed as district superintendent to the California district in 1912. He served until 1939, when the Lighthouse Service was incorporated into the U.S. Coast Guard. The principal keeper was the "law" of his light station, but the district superintendent was the "law" of the district, and Harry Rhodes ran his district with an iron fist, though fairly. (Courtesy of Skip Rhodes.)

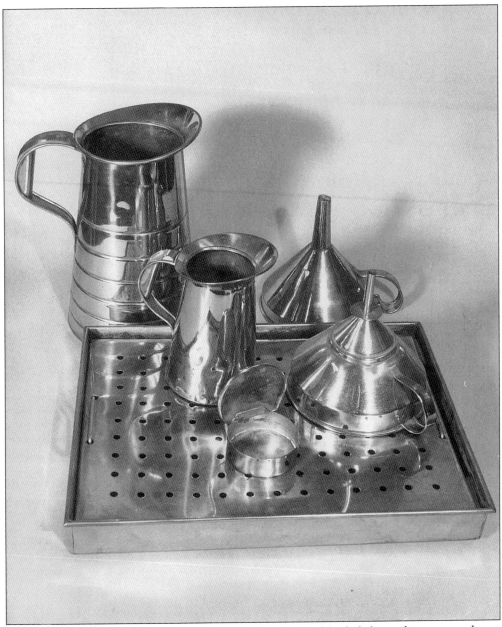

**TOOLS OF THE TRADE.** Some of the brass implements used by lighthouse keepers are shown here. Most of these items were manufactured at the primary Lighthouse Service depot on Staten Island, NY. (U.S. Lighthouse Society photo by Herb Kynor.)

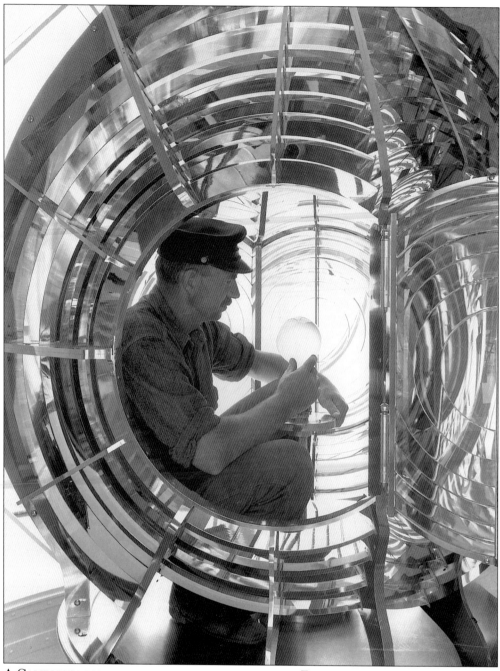

**A CALIFORNIA LIGHT KEEPER, INSIDE HIS THIRD-ORDER FRESNEL LENS, CONTEMPLATING THE LAMP.** Perhaps he is "California Dreaming" during those quieter days along the coast.

# Index